A BETTER 'OLE

THE BRILLIANT BRUCE BAIRNSFATHER AND THE FIRST WORLD WAR

LUCINDA GOSLING
IN ASSOCIATION WITH MARY EVANS PICTURE LIBRARY

The
History
Press

Editor's Note

This book is a rare insight into Bruce Bairnsfather's beautiful and varied images from the First World War. The pictures are laid out to show them to their best advantage, rather than being arranged in chronological order. We hope that you enjoy exploring them for yourself; however, should you wish to reference their chronology, a date has been provided underneath each caption.

Cover image: David Cohen Fine Art/Mary Evans Picture Library

First published 2014

The History Press
The Mill, Brimscombe Port
Stroud, Gloucestershire, GL5 2QG
www.thehistorypress.co.uk

© Text, Lucinda Gosling, 2014
© Images, Mary Evans Picture Library, 2014

The right of Lucinda Gosling to be identified as the Author of this work has been asserted in accordance with the Copyright, Designs and Patents Act 1988.

British Library Cataloguing in Publication Data.
A catalogue record for this book is available from the British Library.

ISBN 978 0 7509 5595 9

Typesetting and origination by The History Press
Printed in Great Britain

INTRODUCTION

On 28 June 1916, an exchange took place in the House of Commons between Mr Wilfrid Ashley and Mr Harold Tennant as MPs discussed the finer details of a new Army Order, forbidding officers and men from publishing any articles and sketches on the war or related military matters without special authority. Mr Ashley asked if the new rule extended to 'drawings such as those which have been published from time to time by Captain Bruce Bairnsfather', to which Mr Tennant confirmed that 'Sketches and drawings will be submitted, when they deal with military subjects, in the same way that photographs and sketches of similar subjects are now submitted'. Mr Ashley then asked mischievously, 'Can the Right Hon. Gentleman guarantee any sense of humour in the Press Bureau?', to which Mr Tennant quipped, 'I should be very sorry to go so far as that.'

There cannot have been many cartoonists who have been name-checked in a parliamentary debate, but Captain Bruce Bairnsfather was no ordinary cartoonist. His cartoons of wartime life in the trenches and beyond were published in *The Bystander* and not only captured the public mood, but also struck a chord with serving soldiers, who recognised themselves and their comrades in the all-too-familiar scenarios depicted by Bairnsfather. They might also recognise the central character of his pictures, a curmudgeonly, wise-cracking, walrus-moustached old soldier known as 'Old Bill' who, together with his sidekicks Bert and Alf, came to epitomise the gruff humour and ingrained stoicism often attributed to the typical British Tommy.

As an officer with the 1st Battalion, Royal Warwickshire Regiment, Bairnsfather was a soldier *and* a cartoonist, someone who could literally draw on first-hand experience for his inspiration; this proximity to the front line gave his work, despite the silliness and jokes, an underlying authenticity. The secret of Bairnsfather's popularity lay in picturing the British soldier very much as he saw himself, and of distilling humour out of what were the darkest of times. In the process, he became unequivocally the best-loved artist of the Great War era.

Charles Bruce Bairnsfather was born in Murree, India (now in Pakistan), in July 1887, the son of an army officer. An artistic streak ran in the family. His mother Janie was a keen amateur artist; his father Thomas had composed 'The Braes o' Strathairlie' published in 1904 and had once had a drawing printed in *The Graphic*. But in an army family, art (particularly illustration) as a legitimate career path was frowned upon and actively discouraged. When Bruce was finally sent to school in England, his parents chose Westward Ho!, a school for army children where his predilection for drawing was seen as a malfunction that could be cured by caning. Showing little academic promise and an aptitude only for drawing and mischief, he spent many of his lessons amusing his schoolmates by drawing caricatures and comic sketches in his exercise books or near-to-hand scraps of paper. In 1904, his parents moved to Stratford-upon-Avon where Bruce attended a crammer, Trinity College, in the hope that he would gain enough of an education to pass his army entrance examination. However, the teenage Bruce was still distracted by his natural instinct for art and began to attend evening classes at Stratford Technical College where the headmaster, a Mr Tom Holte, quickly spotted the boy's potential. Bruce's focus shifted further away from his studies after he sold a drawing for Player's Navy Mixture for 2 guineas. Perhaps unsurprisingly, he failed his exam, much to his parents' dismay. A second attempt was more successful and at the age of 18 he joined the 3rd Militia Battalion of the Royal Warwickshire Regiment, later transferring to the Regular Battalion of the Cheshire Regiment in Lichfield (his father's old regiment) as a second lieutenant. Soldiering did not come naturally to Bairnsfather which, he admitted, 'bored me to tears', and when

his regiment moved to Aldershot away from the music halls of Birmingham – which had provided him with some respite from the daily grind of drilling, route marches and training – he determined to leave the army and set himself on a career path closer to his heart.

Convinced he could make a living as an illustrator, in 1907 he enrolled at the art school run by the great poster and commercial artist John Hassall in Olympia, West London. Tonie and Valmai Holt, Bairnsfather's biographers, point out a number of similarities between Hassall and Bairnsfather, not least the fact that Hassall had failed the Sandhurst entrance examination twice and had explored another career before settling on art (in his case, farming in Canada). At the school, Bairnsfather studied under Charles Van Havermaet, who recognised the young man's talent and gave him extra-curricular lessons. But while he may have been the star pupil on his course, he was dismayed to find the world of commercial art did not seem to show the same level of appreciation, as he faced a growing pile of rejection letters.

Bairnsfather needed the security of regular work and took a job with Spencer's, a firm of lighting engineers in Stratford close to the family home in Bishopton. Beginning as an assistant, he rose steadily through the firm and was eventually given the job of lighting stately homes belonging to aristocratic and wealthy clients, a role that often required him to live in while seeing a project through. He would sketch in the evenings, drawing admiring comments from his well-to-do hosts. He had just returned from a job in Newfoundland in August 1914 when war broke out. Spencer's gave him his notice, leading a jobless Bairnsfather to do what thousands of others did – he enlisted, joining his old regiment. He was commissioned on 12 September into the 3rd (Reserve) Battalion of the Royal Warwickshire Regiment and in October crossed the Channel, travelling to join the 1st Battalion as a machine-gun officer in the trenches near Armentières. It was here that on Christmas Day 1914 Bairnsfather took part in one of a series of fraternisations between British and German men along the Western Front. He exchanged jacket buttons with one German officer and posed for a group photograph commenting, '[I] had ever after wished I had fixed up some arrangement for getting a copy.'

SYD CHAPLIN

as OLD BILL

in "The BETTER 'OLE"

Based upon the play by
Bruce Bairnsfather
and
Arthur Eliot

Directed by
Charles Reisner

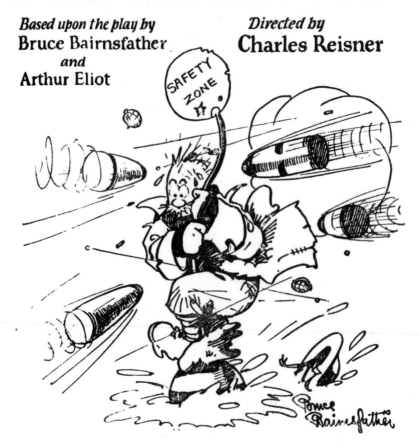

THE STORY OF OLD BILL AND HIS PALS AMID THE BILLETS
AND BULLETS OF THE WAR

A BULL'S EYE! A Tornado of Laughter !

THE FUNNIEST, MOST UPROARIOUS COMEDY EVER SEEN!

The drawing bug had never left Bairnsfather and soon he was entertaining his fellow officers with quick sketches on whichever surface he could find – from ration papers to the walls of the cottage behind the lines where he was based. Temporarily stuck for drawing materials, some of his first pictures on the cottage wall were executed with soot from the chimney and oil from the butt trap of a rifle. Trench life had come as a shock to him, but the pleasure he gained from drawing (and the joy it gave others) offered him some sort of coping mechanism. Several of his comrades suggested he submit his draw-ings to one of the illustrated papers, an idea he began to consider seriously. Recollections regarding his decision to send a drawing to *The Bystander* vary slightly. In his autobiography, *Bullets and Billets*, he describes how he had been sent a number of magazines from home, *The Bystander* among them, but he appears to have spent time weighing up the pros and cons of each publication before making his decision:

> I turned over the pages and considered for a bit whether my illustrated joke might be in their line. I thought of several other papers, but on the whole concluded that the *Bystander* would suit for the purpose, and so, having got the address off the cover, I packed up my drawing round a roll of old paper, enclosed it in brown paper, and put it out to be posted at the next opportunity.

In an interview with *The Graphic* in December 1917, the magazine's ver-sion implicates the hand of fate, presenting his choice of *The Bystander* as almost predestined:

> He only acted when he removed the packing of a parcel sent him from home and found that packing to be a *Bystander*. Here was a sort of hint from Providence to 'send something to the papers,' was it not? He had the picture, 'Where Did That One Go?' by him, and he posted it off to the *Bystander* in London.

Opposite: Old Bill as a movie star – a poster for *The Better 'Ole* film released by Warner Bros. in 1926. The film was financially advantageous to Bairnsfather, but he admitted it bore 'scarcely any resemblance to the play that Eliot and I had once written, and no resemblance whatever to the first film'.

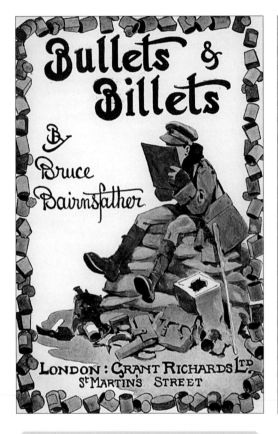

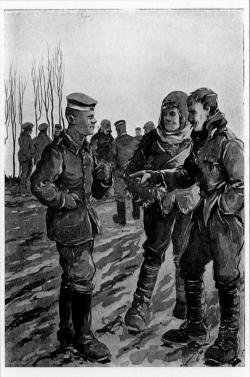

A MEMORY OF CHRISTMAS, 1914: "LOOK AT THIS BLOKE'S BUTTONS, 'ARRY. I SHOULD RECKON 'E 'AS A MAID TO DRESS 'IM"

Frontispiece for *Bullets and Billets*, Bairnsfather's light-hearted memoir of his early wartime experiences.

Bairnsfather took part in the Christmas truce of 1914, exchanging buttons with a German officer and later expressing regret that he had neglected to take down contact details in order to receive copies of photographs taken at the time.

Whichever version is correct, it now seems entirely appropriate that it was *The Bystander* that was selected. Launched in 1903, as a sister paper to *The Graphic, The Bystander* was a witty and irreverent blend of articles on political gossip, society, theatre, motoring, sport and travel, garnished with abundant illustrations and cartoons by prominent artists of the day such as Edward Tennyson Reed and Alick P.F. Ritchie.

The magazine's editor, Vivian Carter, clearly saw some potential in Bairnsfather's drawing and wrote back to him saying, 'We shall be very glad to accept your sketch.' A cheque for £2 was enclosed, along with a request for further drawings. 'Where Did That One Go?' appeared in *The Bystander* on 31 March 1915 and was accompanied by an explanatory caption:

A Sketch from the Front

A reproduction of a sketch sent home to us from the Front by an officer of the 1st Royal Warwicks. 'I have drawn it,' he writes, 'as well as I can under somewhat difficult circumstances, and, I may say, from first hand impressions.'

The picture, showing a motley assortment of British Tommies peering with saucer eyes out of a dugout or shelter as a shell exploded above them, was inspired by true-life events after Bairnsfather had endured a similar experience while under shellfire in the cottage at St Yvon.

He recounted it in *Bullets and Billets*:

We were all inside the cottage now, with intent, staring faces, looking outside through the battered doorway. There was something in the whole situation which struck me as so pathetically amusing that when the ardour of the Boches had calmed down a bit, I proceeded to make a pencil sketch of the situation.

'Where Did That One Go?' was followed on 21 April with 'They've Evidently Seen Me', a wry comment on Bairnsfather's own attempts as a sniper.

Bairnsfather would see the published results of his work while recuperating in the 4th London General Hospital at Denmark Hill. He had been injured in a shell explosion on 24 April during the 1st Battle of Ypres and was suffering from a damaged ear and shell shock, a culmination of the stress and fear he had been suppressing over the previous months. He was surprisingly candid about his mental breakdown, even admitting it in his profile by *The Graphic*.

> Oh, yes, a German shell about knocked me into jelly, and I came back to 'Blighty' with very blighted physical prospects. However, I got over my wounds, although I suppose one is never quite the same after the kind of knock-out I had. But what lingers most vividly with me is this impression, that I was mentally knocked-out before I was blown over physically. For many months I had been in the trenches, and the whole thing, this terrible antagonism of human beings ranged against each other became a nightmare of the imagination. Everything, as you look out on war at close quarters, seems to rise up against you, the tree which will be a sign for a German shell, the house which will fall on you if it happens to be struck – the whole landscape is torture. Some temperaments might never feel it that way, but to me the mental suffering was acute, and instinctively, perhaps, I sought relief in laughing at it all, at the very desperateness of the affair.

Indeed, after a few weeks of recovery, Bairnsfather turned to drawing once more, which he found a welcome and soothing distraction from the horrors preying on his imagination. He drew an advertisement for Beecham's tablets, which might also have been drawn from life showing, as it did, a woozy-looking convalescent soldier in hospital, ubiquitous cigarette hanging from his smiling lips, as a young nurse takes his temperature. It was published in *The Graphic* in June 1915 with a caption giving background information:

> The Officer, whose previous designs were drawn while at the front, is now at home, and writes – 'I have just emerged from Hospital having been docked for repairs owing to being knocked out by a "Jack Johnson" at Ypres.

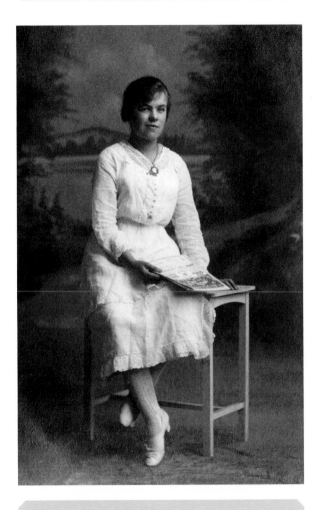

The Bystander, launched in 1903 as a sister paper to *The Graphic*, enjoyed huge popularity both on the Home Front and with fighting men during the First World War fuelled in part by Bairnsfather's cartoons. The copy held by the girl in this photograph features one of Bairnsfather's masthead designs.

I am now strong enough to wield a pen again, although I have not quite regained full control of my hands.'

While in hospital, he was also visited by a member of the *Bystander* staff. The response from readers to Bairnsfather's debut pictures had been so overwhelmingly positive, they were about to make him a life-changing offer – £4 per week if he were willing to provide them with a picture each issue. Bairnsfather accepted.

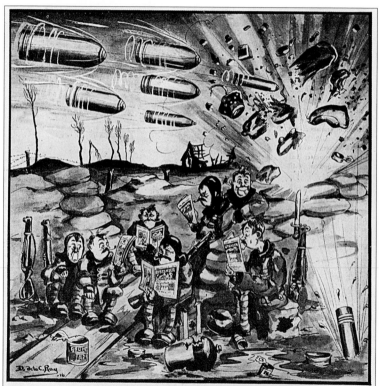

SEEING THEMSELVES AS BAIRNSFATHER SEES THEM
Another soldier-artist has sent us, with his apologies to Capt. Bairnsfather, this sketch of a famous battalion on the Flanders front as it appears on the arrival of its weekly batch of "Bystanders"
BY MAJOR D. DE LA C. RAY

Right: Poster advertising *Fragments* magazine published by *The Bystander* and edited by Bairnsfather. Designed to provide a vehicle for their star artist beyond the war, the magazine ran from 1919 to 1920 and at a cost of 2*d* was aimed at an ex-serviceman readership. At its height, it sold a staggering 7 million copies a week. This poster features Old Bill planning to wave off the Prince of Wales on his tour of Canada.

Opposite: The popularity of Bairnsfather within just a year of having his first cartoon published is evident here in a recognisable homage drawn by officer and amateur artist Major D. de la C. Ray. It was published in *The Bystander* on 5 April 1916.

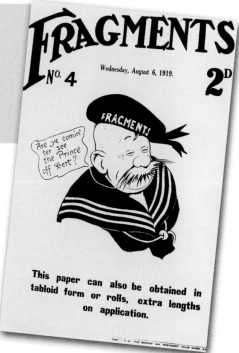

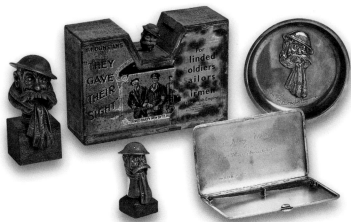

Left: Old Bill and friends were destined to become immortalised on a wide range of merchandise such as these items, which include a cigarette case, mascots, an ashtray and a collection tin produced for St Dunstan's Home for Blinded Soldiers and Sailors.

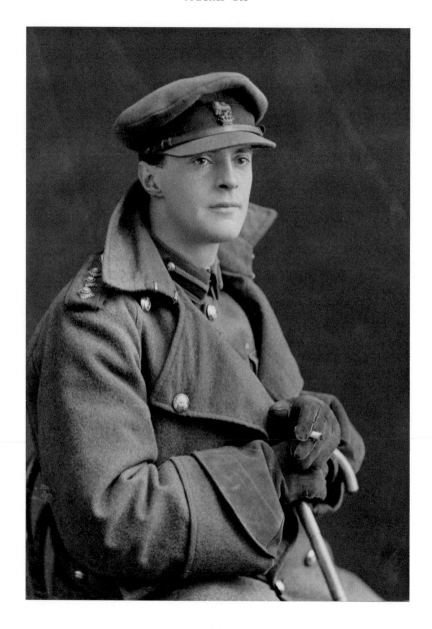

After that, a Bairnsfather cartoon featured almost every week in *The Bystander* and Bairnsfather finally began to enjoy the kind of success he had hoped for as an art student. The 24 November 1915 issue of *The Bystander* saw the publication of what would become his most famous cartoon. Under the title, 'One of Our Minor Wars – "Well, if you knows of a better 'ole, go to it"', it was an instant hit with its readers both at home and at the front, summing up, as it did, that most elemental of human conditions – discontent. The scenario of two hapless Tommies marooned in a shell hole in No Man's Land during a heavy bombardment and bickering over their predicament conjured humour out of the blackest of situations and epitomised both the dry wit of the typical British Tommy, as well as his admirable (if grumpily borne) fortitude. 'The Better 'Ole' cartoon sealed Bairnsfather's status as the magazine's headline act. Bairnsfather and *The Bystander* as a partnership had got off to a good start and it was to be a long and fruitful relationship, though probably less so for the artist. *The Bystander* owned all copyright and controlled the licensing of Bairnsfather's work, a far more profitable arrangement for them, and they proceeded to wring as much publicity and commercial potential as possible from their new signing.

In early January 1916, 'The Better 'Ole' cartoon was reproduced in colour on the front cover of the first dedicated collection of forty-one Bairnsfather drawings. Costing 1s, the portfolios were named *Fragments from France*. *The Bystander* would follow this up with *More Fragments from France, Still More Fragments from France* and in total publish eight separate volumes of Bairnsfather's cartoons over the next three years. In a typically cheeky advertisement for the first *Fragments*, *The Bystander* suggested buying two copies to send to the front – one 'for him for himself, and one to throw to the Germans'! Bairnsfather fans could also order high-quality sets of colour prints in varying finishes, as well as bound versions of the magazine or colour photogravure postcards to preserve for posterity. The publication of *Fragments* was eagerly

Opposite: Bairnsfather cut a handsome figure in uniform during the war. *The Bystander* published his photograph on several occasions and he soon became a recognisable celebrity, though he would often admit to being publicity-shy.

anticipated. In its 1 July 1916 issue, *The Graphic* (which, as the parent magazine to *The Bystander*, had a stake in Bairnsfather's success) printed a whole page of photographs showing how 'the London Book Stall managers celebrated "Fragments" day'. The railway station bookstalls of all London's major terminals were literally festooned with countless copies of the magazine – not only did it look highly effective, it was proof of just how popular Bairnsfather's

The public interest in Bairnsfather's first exhibition of some of his original *Fragments from France* in May 1916 is charmingly captured in this (unattributed) *Bystander* illustration, as crowds gather around the window of the Graphic Galleries at 190 Strand, visibly chortling at the pictures on display.

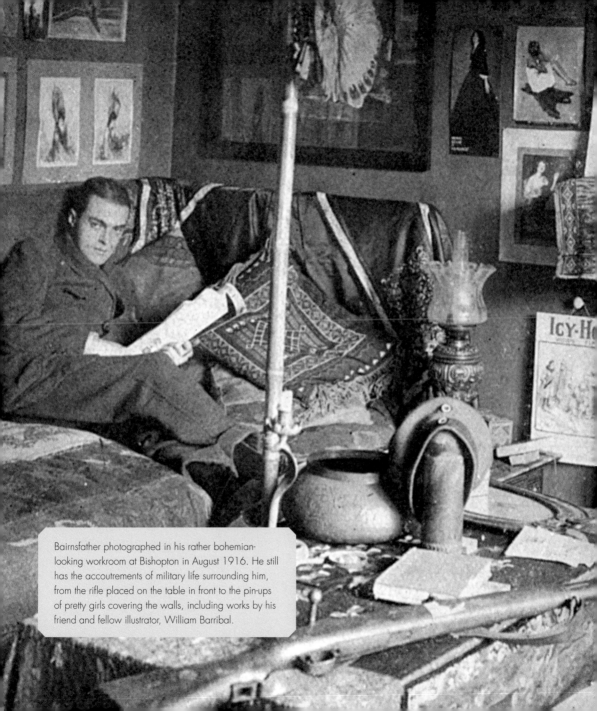

Bairnsfather photographed in his rather bohemian-looking workroom at Bishopton in August 1916. He still has the accoutrements of military life surrounding him, from the rifle placed on the table in front to the pin-ups of pretty girls covering the walls, including works by his friend and fellow illustrator, William Barribal.

war cartoons had become. It is significant that the first volume of *Fragments from France* had sold an extremely healthy 200,000 copies.

Other initiatives came thick and fast. In its 17 May 1916 edition, *The Bystander* advertised an exhibition of 'Fragments from France' by 'the soldier who has made the Empire laugh', opening on Monday 22 May at the Graphic Galleries at 190 Strand. Admission was free and there were opportunities to buy some originals, though *The Bystander* warned, 'Collectors desirous of securing specimens of his work should pay an early visit as several are already sold and many enquiries are being made for others.' A charming illustration, sadly unattributed, was published in *The Bystander* on the day of its opening showing a view of crowds peering through the gallery window, laughing heartily at the pictures they were able to glimpse on display. A second exhibition took place at the same gallery in August the following year.

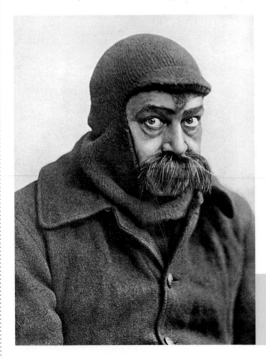

On 28 June that year, *The Bystander* was delighted to print a letter received from a German prisoner in Siberia who advised the magazine that 'our publication, "Fragments from France" has penetrated to the very heart of the Asiatic Continent'. The correspondent went on to assure *The Bystander* that 'Far from being "infuriated" on turning the pages of "Fragments from France," the enemy so far forgot his true nature as to enjoy a very hearty laugh. Situations of the kind so

Arthur Bourchier very much looking the part in the publicity shots taken for his role of Old Bill in 'The Better 'Ole' staged at the Oxford Theatre in 1917.

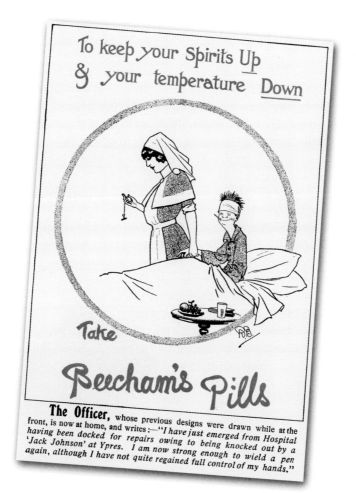

Advertisement for Beecham's Pills illustrated by Bairnsfather and published in *The Graphic* on 5 June 1915. The publication of at least two Beecham's Pills adverts drawn by him during this time suggest he had secured the commission separately, perhaps before he had properly established himself as *The Bystander's* cartoonist; proof of his long-held ambitions to make a living as a commercial artist.

truthfully pictured by Captain Bairnsfather are not exclusive prerogatives of the British.' Sensing there may be some scepticism about the authenticity of the letter, *The Bystander* printed a facsimile of the envelope with its Russian postmark, adding that it had 'all the appearance of genuineness'.

Bairnsfather may have summed up the inherent traits of the British soldier in his drawings, but it appears they were traits that were recognised internationally – even by the enemy. In 1918, in one of its numerous pieces lauding Bairnsfather's brilliance, *The Bystander* noted how he observed 'the humour that rings true in every soldier's language, since it springs from the freemasonry of all fighting men, who laugh at difficulty and at danger as Captain Bairnsfather depicts it'.

Bairnsfather's multi-national appeal was picked up by the French too at the end of 1916, who requested that Bairnsfather be loaned to them in order to sprinkle some of his magic on the morale of their troops. This request and recognition of Bairnsfather's value by the French Army prompted the War Office to acknowledge his contribution to the morale of his own country's forces. He was appointed Officer Cartoonist in the Intelligence Department. Now, his *Fragments* were officially part of the war effort.

Above: Walking cane with a solid silver Old Bill handle.

Right: One of several jigsaws produced by *The Bystander*. This one, number six in the magazine's series, features Bairnsfather's cartoon 'You Wait 'Til I Comes Off Dooty' and has Old Bill absorbed in completing the puzzle on the box cover.

In France, he was feted as a celebrity, toured their lines and had his drawings reproduced in the official magazine of the French Army – *Bulletin des Armées*. His sabbatical with the French was followed later by a trip to Alsace Lorraine where he visited the American troops, and shortly afterwards he travelled to the Italian front where his pictures, embellished with humorous fancy, recorded his time spent with the intrepid Alpini.

His links with the Intelligence Department led to an introduction to a writer, Captain A.J. Dawson, with whom he collaborated on a number of books as illustrator, including *Some Somme Stories* and *To France*. Bairnsfather himself had turned writer as well as artist in 1916 after being signed off active service following his injuries at Ypres. With his star in its ascendency, it was naturally a good time to capitalise on his

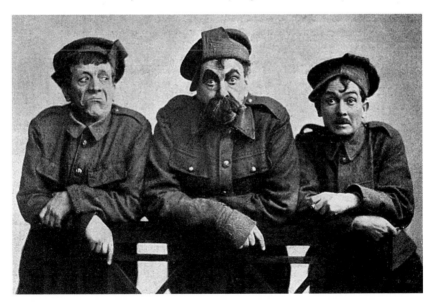

The three leading actors in 'The Better 'Ole' stage play: Arthur Bourchier as Old Bill, Sinclair Cotter as Alf and Tom Wootwell as Bert.

popularity. *Bullets and Billets* was an autobiographical tale of Bairnsfather's own war experiences from 1914 until he was wounded at Ypres. It garnered mixed reviews, as did his sequel, *From Mud to Mufti*, published in 1919, and a somewhat obsequious book by Vivian Carter entitled *Bairnsfather, A Few Fragments from his Life*. However, what these books did was give the public a more detailed insight into the wry and self-effacing personality of Bairnsfather. *The Bystander*, typically, was effusive about *Bullets and Billets*

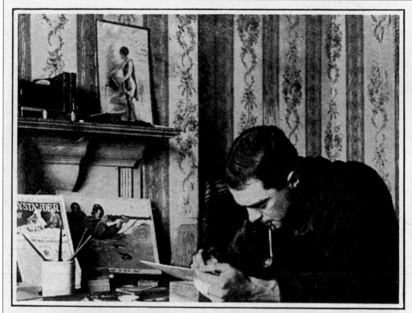

'THE BYSTANDER" WAR ARTIST AT WORK
Captain Bruce Bairnsfather engaged upon one of the humorous war cartoons, which appear weekly in this journal

Bairnsfather, pipe in mouth, hard at work in November 1915. Note the copy of *The Bystander* propped up on the table next to him.

and reminded readers that they could obtain copies from their offices at Tallis House. On 11 April 1917 it was writing, 'Captain Bairnsfather's very own book about the war is going very well indeed.' Having already sold 20,000 copies, it included the testimonial of one letter from the trenches: 'It's simply priceless. I sat up till two reading it, and was simply chortling all the time.'

A month later, it was reported that it was selling 'like hot cakes with the ordinary edition now in its fourth impression, more than 50,000 copies having already been sold'. They are the kind of sales figures most publishers today can only dream about.

Bairnsfather's foray into writing did not stop there and soon he was able to add playwright to his growing list of talents. The theatre and music hall was one of his great loves since he had visited the theatres of Birmingham as a young man, and for some time he had been toying with the idea of adapting his cartoons for the stage. In September 1916, a sketch, 'Bairnsfatherland', penned by Bairnsfather and Lance Corporal B. Macdonald Hastings, was the star attraction in a revue, 'Flying Colours', at the Hippodrome. Set, according to the programme, 'near Plugstreet Wood, during one day in the trenches about Christmas time, 1914', tongue-in-cheek credits were also given to the 'Ypres Armentière & Co' for the shells and mud, and to 'Plum and Apple (un)Limited' for the discarded tins (the ubiquity of plum and apple jam as rations for troops was a repeating joke in Bairnsfather's work). The audience, remarked *The Bystander*, 'contained quite an unusual proportion of khaki', and caught every point of the sketch immediately, 'from first to last amid a storm of laughing and cheering that guaranteed its complete success'. The role of Old Bill, fast becoming the central character in Bairnsfather's cartoons and described by *The Bystander* as 'the war-worn soldier who looks like a sea-lion', was played with aplomb by John Humphries, while Charles Berkeley played his sidekick Bert. Humphries reprised the role six months later when another Bairnsfather sketch, 'Where Did That One Go?', was featured in 'See-Saw' at the Comedy Theatre.

The Bystander's theatre columnist, Jingle, gave a summary of the plot for its readers:

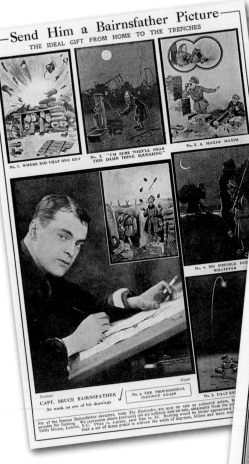

In January 1916, *The Bystander* issued a number of Bairnsfather's images as colour prints and promoted these heavily in the magazine, suggesting they would make an ideal gift to send to the trenches.

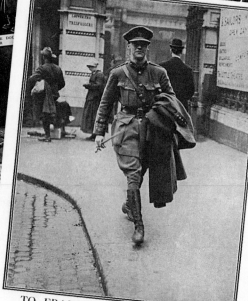

'To France for "Fragments"' – Bairnsfather featured on the front cover of *The Bystander*, 8 November 1916.

The scene is, of course, 'Somewhere in France,' and the chief characters are our very dear friends, Old Bill, Bert, and Alf, who seem able to manufacture dry humour of the best kind even under shell-fire. The humour of the situation is increased by the fact that the storm-centre of the moment is at the Café de la Paix, the roof of which is blown off before our very eyes. The discovery that the explosion has apparently hit the till and has scattered a few francs broadcast is naturally of supreme interest to the impecunious Tommies, though it is shown in a most diverting manner that they have missed the real prize of the occasion – the proprietor's strong-box.

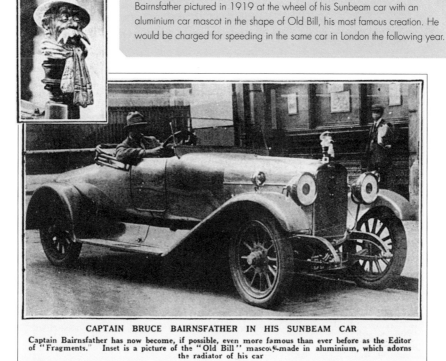

Bairnsfather pictured in 1919 at the wheel of his Sunbeam car with an aluminium car mascot in the shape of Old Bill, his most famous creation. He would be charged for speeding in the same car in London the following year.

CAPTAIN BRUCE BAIRNSFATHER IN HIS SUNBEAM CAR
Captain Bairnsfather has now become, if possible, even more famous than ever before as the Editor of "Fragments." Inset is a picture of the "Old Bill" mascot made in aluminium, which adorns the radiator of his car

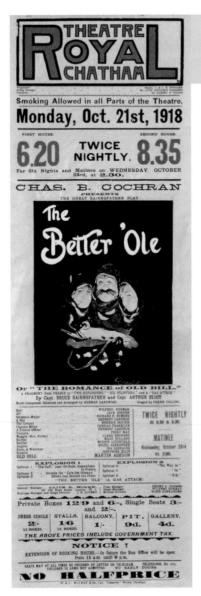

Poster advertising 'The Better 'Ole', which had travelled to the provinces by 1918, in this case to Chatham, where Martin Adeson was playing the part of Old Bill at the Theatre Royal.

Humphries was the first in a line of actors to play Old Bill, a character whose physical traits were integral to the personality he projected on stage. The genesis of Old Bill was regularly speculated upon in the press. Many figures from Bairnsfather's past claimed to be the original inspiration for the gruff soldier, including his old art teacher John Hassall and, going even further back, his headmaster at Westward Ho! But Bairnsfather would always insist that Old Bill was a gradual evolution, whose character was the culmination of many years' observation and exposure to a variety of examples within a particular 'type'. In its 13 November 1918 issue, *The Bystander* ruminated on the origins of Old Bill:

The fact is, of course, that Old Bill is not a portrait at all. He was built up in the manner familiar to all creators of popular characters, a bit from here and a bit from there. His extraordinary popularity is due to the fact that he represents not an individual, but a type composed of many examples. This obvious fact however, does not deter optimists from asserting that they are the only originals in the case. Some of them even go so far as to send

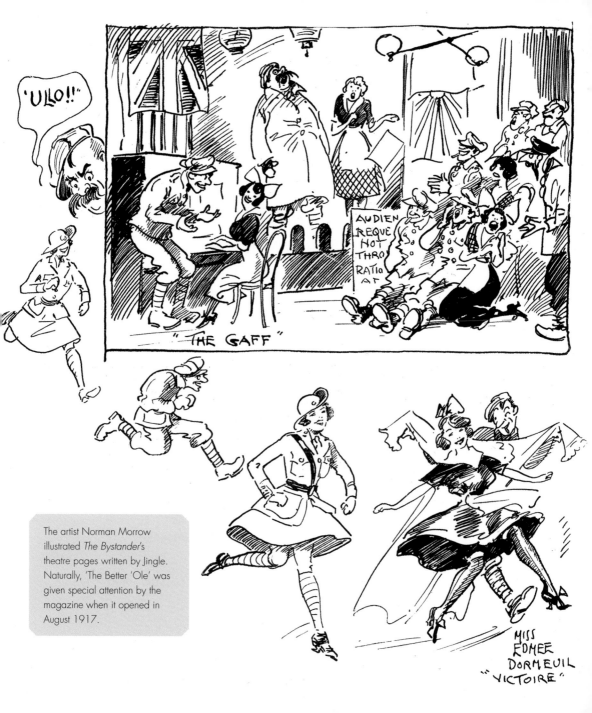

The artist Norman Morrow illustrated *The Bystander*'s theatre pages written by Jingle. Naturally, 'The Better 'Ole' was given special attention by the magazine when it opened in August 1917.

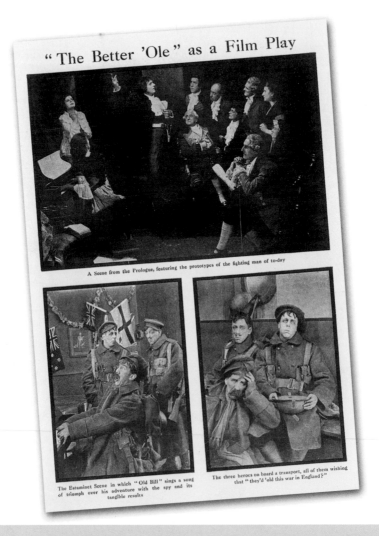

"The Better 'Ole" as a Film Play

A Scene from the Prologue, featuring the prototypes of the fighting man of to-day

The Estaminet Scene in which "Old Bill" sings a song of triumph over his adventure with the spy and its tangible results

The three heroes on board a transport, all of them wishing that "they'd 'old this war in England?"

Scenes from the film version of 'The Better 'Ole', produced by Welsh Pearson in 1918. Charles Rock played the main role of Old Bill, Arthur Cleave was Bert and Hugh E. Wright played Alf.

their photographs as collateral evidence, so to speak, of their unimpeachable veracity ... The grim old soldier, with a rough and ready wit, who was a little less tolerant of the younger and greener men with whom he had to serve, was a very common object of the trenches in the early days of the war. There are many examples of his kind in Captain Bairnsfather's earlier sketches, before they were gradually combined into a single composite character and Old Bill was evolved for the world's delight.

Bairnsfather particularly cited the weeks he had spent in July 1916 at the Albany barracks on the Isle of Wight after he was given light duties following his convalescence. Inevitably, during this time spent training and rehabilitating men to replace the casualties suffered by his regiment, he was exposed to a number of Old Bill types. There he was in charge of 200 veteran soldiers, the 'Old Contemptibles', whom he had a deep-seated affection for, having served alongside them in France. 'I love those old work-evading, tricky, self-contained slackers – old soldiers. They are the cutest set of rogues imaginable, yet with it all there is such a humorous, childlike simplicity,' observing how despite all their work-shy tricks, they were,

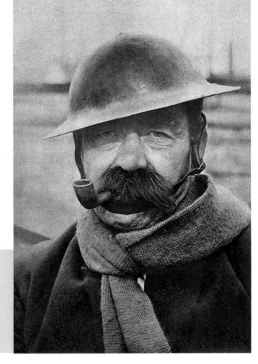

In 1919, *Fragments* magazine ran an Old Bill lookalike competition and a portrait of the winner, a Mr Samuel Birkenshaw of Eldon Street, Oldham, complete with bulbous nose and the obligatory walrus moustache, was published in *The Bystander*.

at heart, loyal and fearless: 'If you were lying wounded in the middle of a barrage, that same man would come and pull you out.'

In 1917, a 'new' Old Bill was to make an appearance when a full-length stage play, 'The Better 'Ole' or 'The Romance of Old Bill', described as 'A Fragment from France: in Two Explosions, Seven Splinters, and One Gas Attack', was staged at the Oxford Theatre in London by leading theatrical impresario Charles B. Cochran. The play, written by Bairnsfather and his co-writer Captain Arthur Elliot, opened on 4 August and starred Arthur Bourchier in the lead role. Bert and Alf were played by Tom Wootwell and Sinclair Cotter respectively, while French actresses Edmée Dormeuil and Germaine Arnaux added an authentic touch. *The Graphic* commented on 'some good songs, and some pretty girls and some striking scenery designed by Captain Bairnsfather', explaining that 'It is not a play in the strict sense; it is

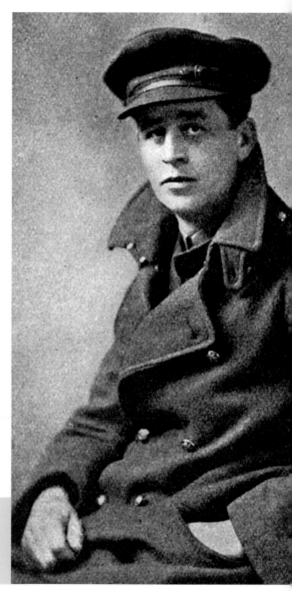

Captain Arthur Eliot, co-writer with Bairnsfather of the play 'The Better 'Ole'. Eliot was attached to the Indian Division in France during the war.

Example of the Bairnsfatherware pottery produced by Grimwades of Stoke-on-Trent featuring 'The Better 'Ole' cartoon in the centre and with Bairnsfather-designed wartime paraphernalia decorating the plate's edge.

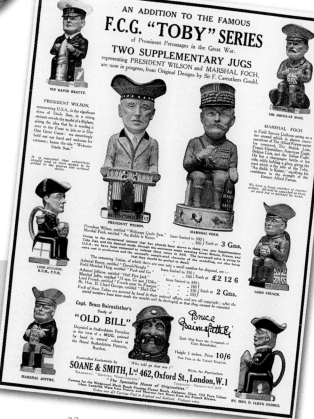

Old Bill taking his rightful place alongside other celebrated wartime figures as a Toby jug in a range available from Soane & Smith Ltd of Oxford Street, London.

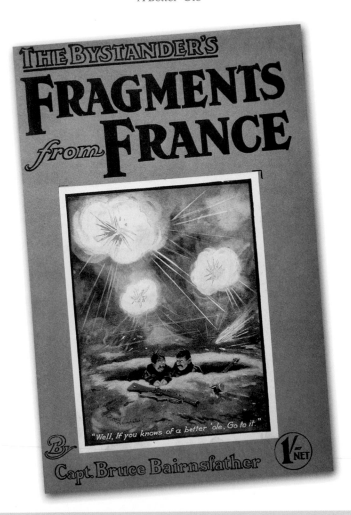

This first volume of *Fragments from France* was published in January 1916 and would be followed by seven more. Colour versions of some of Bairnsfather's most popular cartoons were pasted onto the cover of each *Fragment* volume. The first, unsurprisingly, featured his hugely popular 'The Better 'Ole' cartoon.

a dramatic amalgam of all the characteristics, kindly, humane and comforting, which have made Bairnsfather a household word, plus a little spy story which Old Bill has the honour of unmasking'.

The Times found that:

> The Bairnsfather spirit is perfectly reproduced … Any idea that the Oxford Theatre has gone over to serious drama may be dismissed at once. The Better 'Ole is just good fun and is likely to fill the house for many weeks. A first night audience cheered the play, the actors, the authors, and even Mr Bourchier's singing.

Audience tastes in wartime was for the light and humorous. 'The Better 'Ole' met that requirement perfectly. Various versions were staged in provincial theatres and the Oxford revived it again in 1920. By now, Bairnsfather and Old Bill were part of the country's lexicon. Not only were Bairnsfather's cartoons issued as portfolio prints and postcards, but now *Fragments* were being reproduced on playing cards by Charles Goodall in 1916, as a calendar published by A.V.N. Jones and Company (for 1918), as dolls produced for Red Cross fundraisers, jigsaws, ash trays and even as a bronze car mascot produced by Louis Lejeune (Mascots) Ltd at a cost of 2½ guineas. Bairnsfather was proudly displaying one such mascot on his own car – a Sunbeam – when he was found speeding while driving up Constitution Hill on 29 June 1920.

Several versions of an Old Bill doll appeared during the war. This less sophisticated model was given away as a souvenir by the actress Lee White at the popular revue 'Cheep!', staged at the Vaudeville Theatre in 1917. Miss White, despite her gender, played an Old Bill-type character in a sketch entitled 'With the Lads (God Bless 'Em)' and at the end, following her rendition of 'Where Did That One Go?', the khaki doll was thrown into the audience as a memento for anyone lucky enough to catch one.

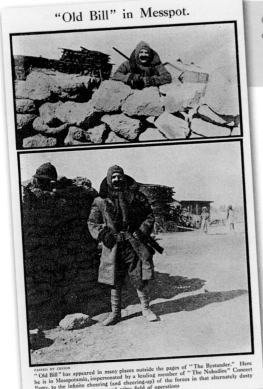

"Old Bill" in Messpot.

PASSED BY CENSOR
"Old Bill" has appeared in many places outside the pages of "The Bystander." Here he is in Mesopotamia, impersonated by a leading member of "The Nobodies" Concert Party, to the infinite cheering (and cheering-up) of the forces in that alternately dusty and rainy field of operations

Old Bill turned up in the unlikeliest of places. Here, a leading member of 'The Nobodies' Concert Party for entertaining troops in Mesopotamia offers a rather brilliant impersonation.

Bairnsfather fans could even eat their dinner off his cartoons when in 1917 Grimwades Pottery of Stoke-on-Trent began to mass-produce a range of pottery items which became collectively known as 'Bairnsfatherware'. Featuring numerous versions and permutations of plates, teapots, butter dishes, serving dishes, shaving cups and vases, the pieces featured some of the best-loved *Fragments* including, 'Where Did That One Go?', 'The Better 'Ole' and 'When the 'Ell is it Going to be Strawberry?' Products continued to be manufactured into the 1920s, but some of the earliest examples are stamped on the back with a patriotic message: 'Made by the Girls of Staffordshire during the winter of 1917 when the boys were in the trenches fighting for liberty and civilisation.' Perhaps the most natural manifestation of *Fragments*' success was in 1918 when Old Bill joined Marshal Foch, Lord French and Lloyd George as a Toby jug, manufactured by Soane & Smith.

Having conquered the stage, it seemed predestined that Old Bill should next grace the silver screen, and at the beginning of 1918 Welsh-Pearson, a new production company formed by two former executives at Gaumont

Pictures, began work on Bairnsfather's 'The Better 'Ole' at Craven Park Studios. This time, Charles Rock played Old Bill, Arthur Cleave was Bert and Hugh Wright played the role of Alf. Eight years later Warner Bros. released their own version, starring Syd Chaplin (brother of Charlie) in the lead role. The film was financially advantageous to Bairnsfather but he admitted it bore 'scarcely any resemblance to the play that Eliot and I had once written, and no resemblance whatever to the first film'.

After the armistice, Bairnsfather continued to draw for *The Bystander* magazine (in fact, he would continue to submit drawings to them periodically until the magazine's merger with *The Tatler* in 1940). Many of the themes dealt with the preoccupations of post-war Britain – demobilisation, strikes, Bolshevisim, reconstruction and remembrance. *The Bystander*, recognising that there

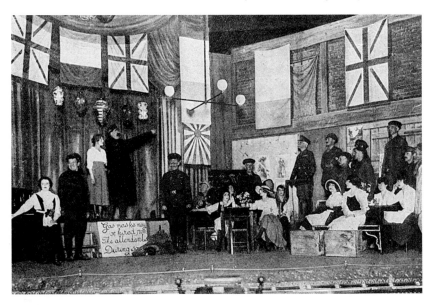

Scene from 'The Better 'Ole' at the Oxford Theatre in August 1917. Old Bill is singing 'If You Were the Only Girl in the World' but is interrupted by the entrance of his colonel.

were still topics aplenty for Bairnsfather to mine, decided to provide him with a new vehicle for his talents: *Fragments* magazine, with Bairnsfather as editor and main contributor, was launched on 16 July 1919. In comparison to *The Bystander*, which retailed at 9*d* by the end of the war, *Fragments* cost just 2*d* and was aimed at an ex-serviceman readership. It was a triumph and at the height of its success in October 1919 was selling a staggering 7 million copies. It also offered all those claimants to the title of the original Old Bill an opportunity to enter a lookalike competition. The winner, Mr Samuel Birkenshaw of Oldham, was pictured in *The Bystander* on 8 October, his bristling moustache and bulbous nose sufficient justification for his claims!

While Mr Birkenshaw's period of celebrity was brief, for Bairnsfather, Old Bill and the fame his association with *The Bystander* brought him was to sustain a long, if chequered, career beyond the First World War. Bairnsfather often spent long periods abroad, particularly in North America, where he was in demand on the lecture tour circuit. One of the first of Bairnsfather's talks, entitled 'Old Bill and Me', was held at the Queen's Hall in London on 29 January 1919. Presiding over the lecture was General Sir Ian Hamilton, one of the few establishment figures to champion Bairnsfather's essential

" Where Did That One Go ?"

A compliment from one great cartoonist to another. H.M. Bateman, best known for his scenes depicting social faux pas in *The Tatler*, offers his own version of 'Where Did That One Go?' in a golfing cartoon published in *The Bystander*, 15 October 1919. The cartoon is a remarkable blending of his own and Bairnsfather's artistic styles.

morale-boosting role. He spoke glowingly of the artist, calling him 'a great asset – the man who had relieved the strain of war, who had drawn a smile from sadness itself by his skill in poking fun at tragedy'.

Back in 1916, at the height of the war when the first volume of *Fragments from France* was published, *The Bystander*'s editor, Vivian Carter, used some journalistic licence to conjure a scenario where Bairnsfather's creative spark had been a direct consequence of his experiences in the trenches, writing, 'Without the war, he might never have put pencil to paper for publication.' It was entirely untrue of course; Bairnsfather had hoped to make a living as an artist since his days at John Hassall's art school. Although the romance of the story was intended only as a canny marketing ploy, it misleadingly pictured Bairnsfather as an accidental amateur illustator – a factual indiscretion that Tonie and Valmai Holt believe handicapped Bairnsfather in terms of being accepted as a bona fide artist, which was, despite the varied roles he inhabited, his first love.

Would Bairnsfather have had the same success in any other era? It is debatable. His style is not to everyone's taste, but for depicting the sheer uncomfortable grimness of life at the front, it seems eminently suitable. His

1920 advertisement for the Old Bill car mascot, exclusively sold by S. Smith & Sons 'of Motor Accessories fame'.

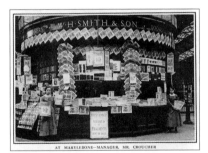

Fragments Day – the W.H. Smith & Son bookstall at Marylebone station on the day *More Fragments from France* was launched in June 1916. Bookstalls at all London's train stations exhibited similar impressive displays.

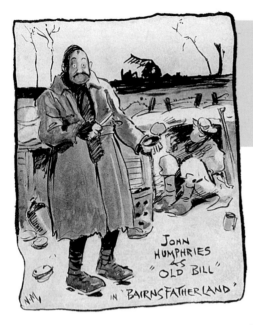

JOHN
HUMPHRIES
AS
"OLD BILL"

IN "BAIRNSFATHERLAND"

N.M.

Old Bill's first outing on stage was in a sketch entitled 'Bairnsfatherland' as part of the revue 'Flying Colours' at the Hippodrome in London, where he was played by John Humphries. Humphries' portrayal is captured here in *The Bystander* by Norman Morrow in its 27 September 1916 issue.

muddy colour palette echoes the murk and damp of the trenches, and the bouncing vivacity of line serves to emphasise the wit and banter of those Tommies stuck 'somewhere in France'. The characters he shaped and shared with the public were borne of his own experiences as a serving soldier, and his connection with *The Bystander* gave him an enviable launch pad from which to disseminate his easy-to-like brand of comedy.

The cartoons selected for this book were all originally published in *The Bystander* between 1915 and 1920. Many, but not all, also appeared subsequently in *Fragments from France*. It is easy to see how Bairnsfather and his irrepressible rag-tag cast of soldier friends found their way into the hearts of so many a century ago. Though some of the jokes are now a little anachronistic, many of them remain laugh-out-loud funny.

The centenary of the First World War allows us to reflect on many aspects of this terrible conflict and to remember and commemorate the millions who fought and died around the world. But it is also an opportunity to remember and rediscover the contributions to the war effort made by many others, both combatant and non-combatant. In the twenty-first century, when news feeds and images are available at the touch of a button, it is difficult to comprehend the essential and integral role the press, the printed word – and the printed picture – played in the public's psyche. Captain Bruce Bairnsfather's

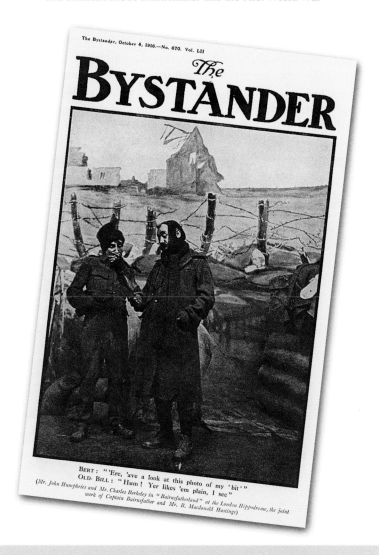

A humorous moment in the Bairnsfatherland sketch in 'Flying Colours' at the Hippodrome, the joint creation of Bairnsfather himself and Basil Macdonald Hastings.

instinctive understanding of what would amuse and cheer the public when it was at its lowest ebb helped seal his popularity and, in the opinion of some, helped win the war. Browsing through these cartoons today, it seems that, despite the passage of 100 years, the characters of Old Bill and Co. are as vibrant and colourful as ever. It is the humour and genius of Captain Bruce Bairnsfather that we have to thank for that.

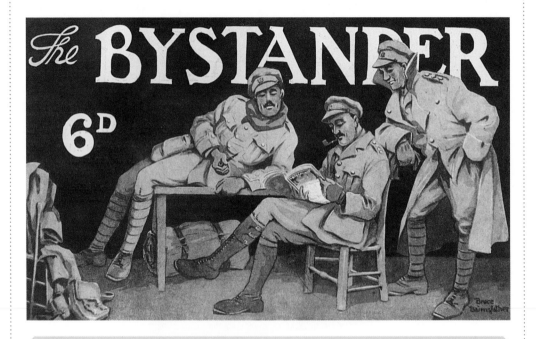

A *Bystander* masthead from January 1917 designed by Bairnsfather depicting what could very well have been a familiar scene – showing officers at the front enjoying the latest edition.

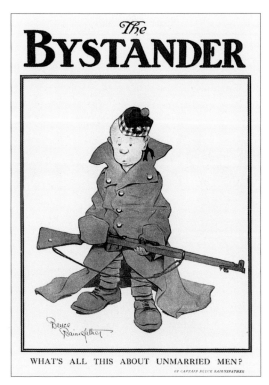

5 January 1916

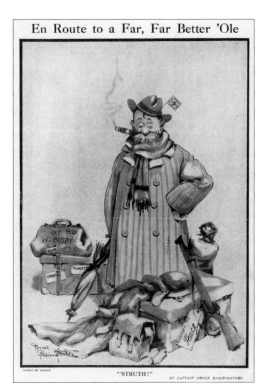

20 November 1918

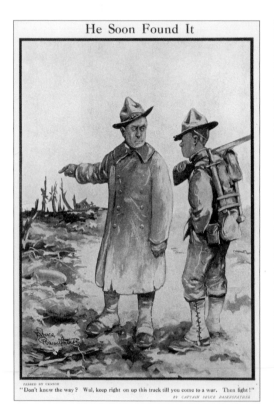

He Soon Found It

"Don't know the way? Wal, keep right on up this track till you come to a war. Then fight!"

BY CAPTAIN BRUCE BAIRNSFATHER

1 May 1918

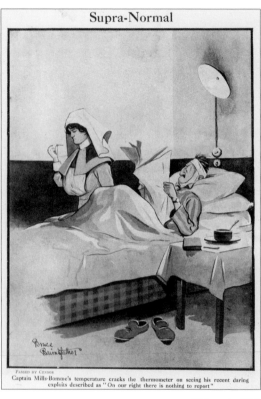

Supra-Normal

Captain Mills-Bomme's temperature cracks the thermometer on seeing his recent daring exploits described as "On our right there is nothing to report"

27 September 1916

A.D. 19 ° ° (?)

29 September 1915

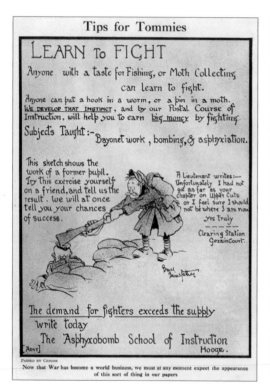

9 August 1916

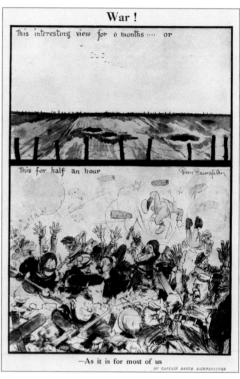

1 March 1916

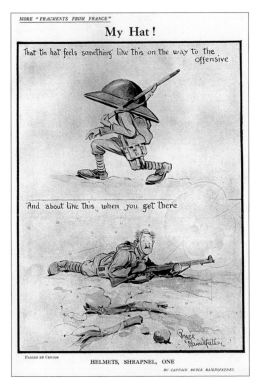

26 July 1916

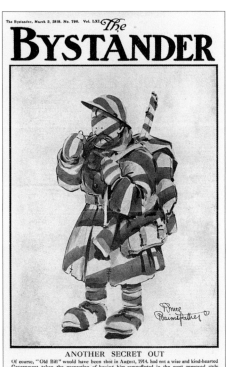

5 March 1919

SHADOWS IN WHITEHALL

13 August 1919

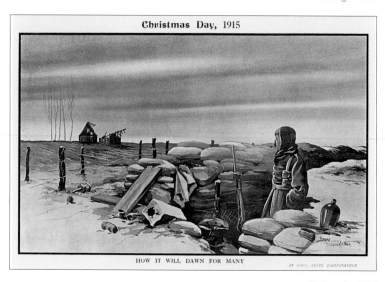

How it will Dawn for Many

22 December 1915

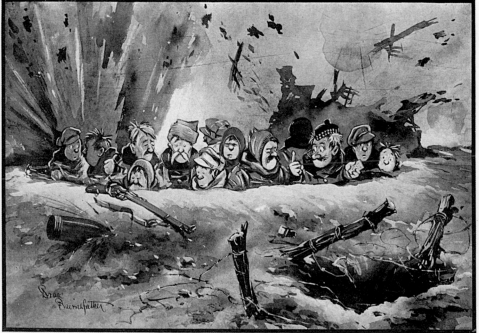

MORE "FRAGMENTS FROM FRANCE"

Those Superstitions

Private Sandy McNab cheers the assembly by pointing out (with the aid of his pocket almanac) that it is Friday the 13th and that their number is one too many

BY CAPT. BRUCE BAIRNSFATHER

16 February 1916

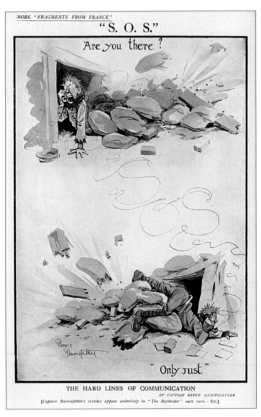

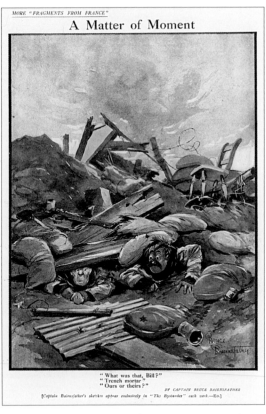

23 February 1916

8 March 1916

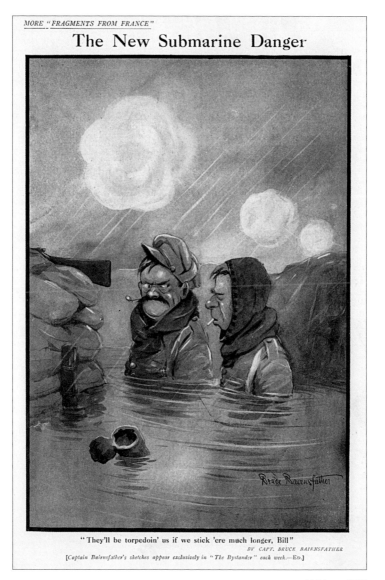

MORE "FRAGMENTS FROM FRANCE"

The New Submarine Danger

"They'll be torpedoin' us if we stick 'ere much longer, Bill"

BY CAPT. BRUCE BAIRNSFATHER

[Captain Bairnsfather's sketches appear exclusively in "The Bystander" each week.—Ed.]

16 February 1916

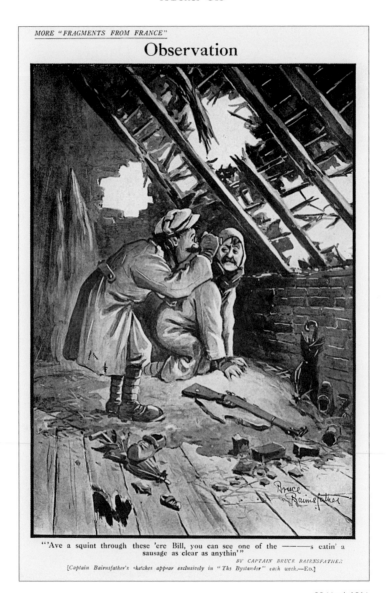

22 March 1916

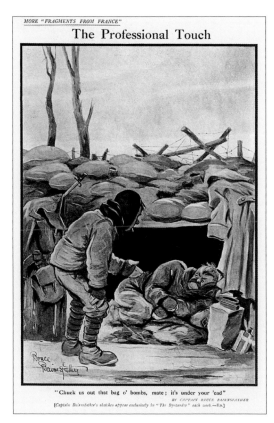

22 March 1916

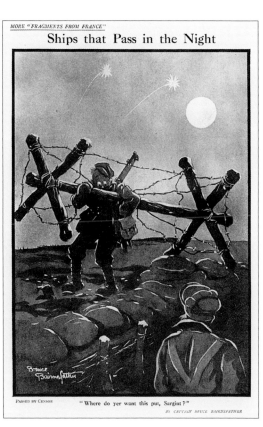

2 August 1916

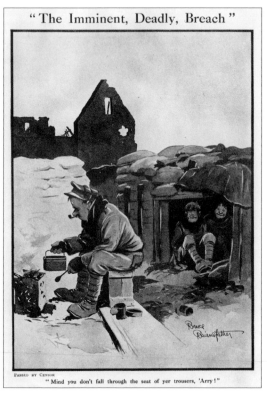

9 August 1916

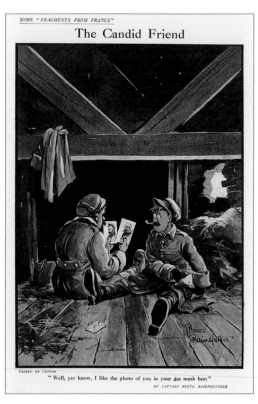

1 November 1916

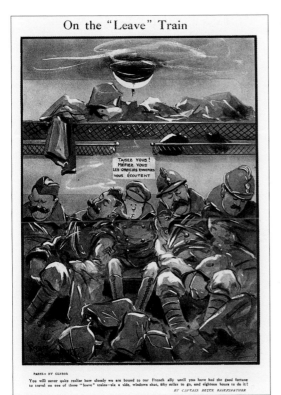

On the "Leave" Train

TAISEZ VOUS !
MÉFIEZ VOUS
LES OREILLES ENNEMIES
VOUS ÉCOUTENT

PASSED BY CENSOR
You will never quite realise how closely we are bound to our French ally until you have had the good fortune
to travel on one of those "leave" trains—six a side, windows shut, fifty miles to go, and eighteen hours to do it !
BY CAPTAIN BRUCE BAIRNSFATHER

20 December 1916

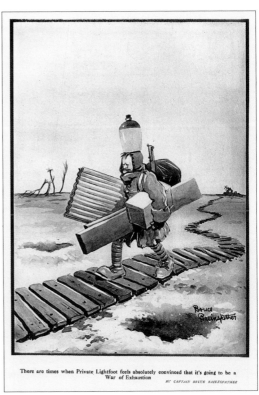

There are times when Private Lightfoot feels absolutely convinced that it's going to be a
War of Exhaustion
BY CAPTAIN BRUCE BAIRNSFATHER

27 November 1916

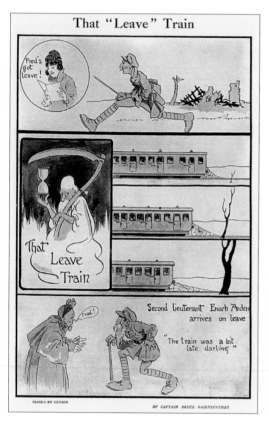

31 January 1917

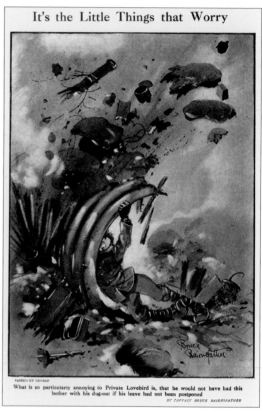

7 February 1917

This Muddy War

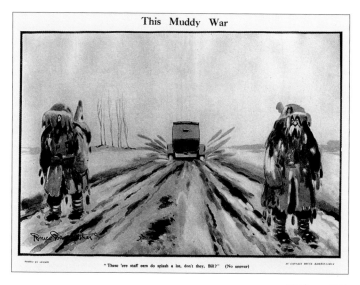

28 February 1917

Those Raiders at the Seat of War

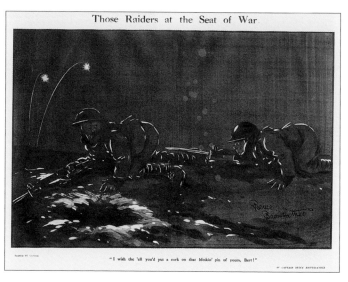

21 March 1917

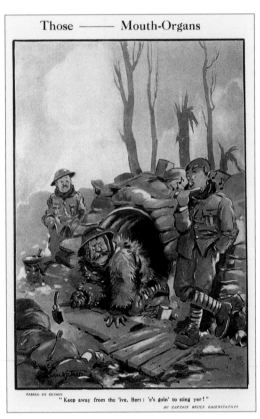

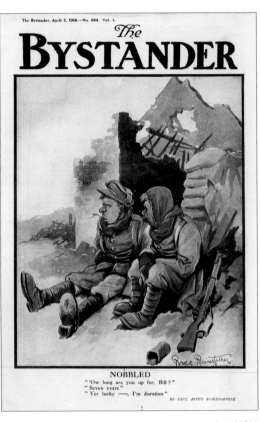

7 March 1917

5 April 1916

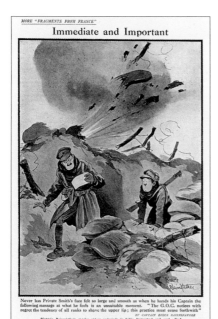

5 April 1916

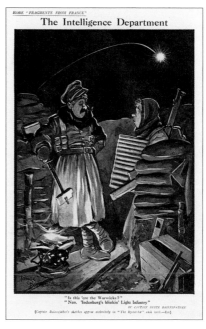

15 March 1916

11 April 1917

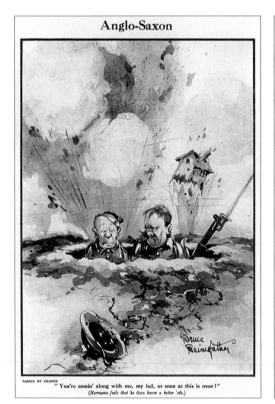

Anglo-Saxon

" You're comin' along with me, my lad, as soon as this is over ! "
(*Hermann feels that he does know a better 'ole.*)

9 January 1918

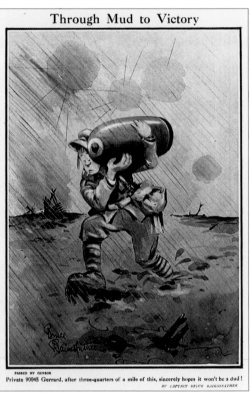

Through Mud to Victory

Private 90045 Gerrard, after three-quarters of a mile of this, sincerely hopes it won't be a dud !
BY CAPTAIN BRUCE BAIRNSFATHER

16 January 1918

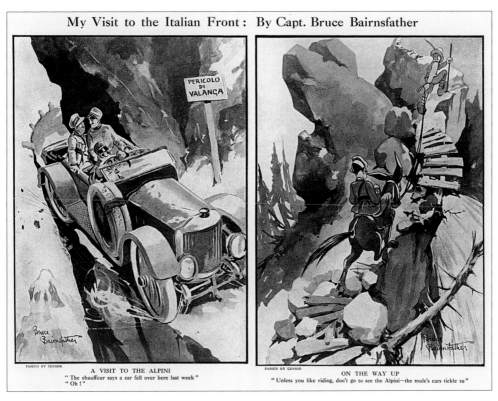

My Visit to the Italian Front : By Capt. Bruce Bairnsfather

PERICOLO
DI
VALANGA

PASSED BY CENSOR
A VISIT TO THE ALPINI
" The chauffeur says a car fell over here last week "
" Oh ! "

PASSED BY CENSOR
ON THE WAY UP
" Unless you like riding, don't go to see the Alpini—the mule's ears tickle so "

6 February 1918

"Lead, Kindly Light . . ."

PASSED BY CENSOR

"Yes, I know the road's rotten; but I'm sure this habit of Sec.-Lieut. Smith's of finding his way back to billets with his private repeating Verey pistol (that his aunt sent him) will lead to trouble"

BY CAPTAIN BRUCE BAIRNSFATHER

23 January 1918

A Visit to the Alpini

PASSED BY CENSOR

THE ALPINI MOUNTAIN HOME

Nearly there: the last 200 metres on foot. The woods seem full of eyes, and the forest echoes that one accusing cry "Inglesi!"

BY CAPTAIN BRUCE BAIRNSFATHER

13 February 1918

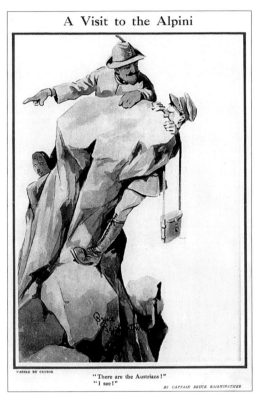

20 February 1918

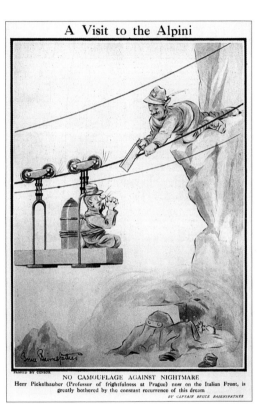

20 March 1918

An Eye for Business

PASSED BY CENSOR

WILLIAM K. FLICKER (*the ex-Movie Producer, after surveying the surrounding civilisation in silent indignation*): "Guess they ought to send this outfit on tour when they've finished here!"

27 March 1918

A Visit to the Alpini

PASSED BY CENSOR

19 * * ?

The war was over some time ago, but this man hasn't heard about it yet, and nobody can get up to tell him. His sniping is therefore very annoying to that Austrian village in the valley

BY CAPTAIN BRUCE BAIRNSFATHER

27 March 1918

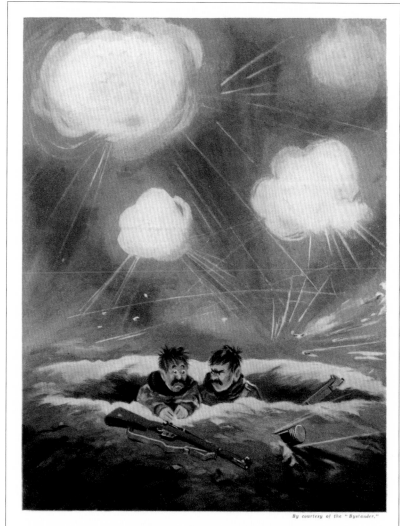

By courtesy of the "Bystander."

"WELL, IF YOU KNOWS OF A BETTER 'OLE, GO TO IT!"

24 November 1915

By courtesy of the "Bystander."

COIFFURE IN THE TRENCHES
"Keep yer 'ead still, or I'll 'ave yer blinkin' ear off!"

10 November 1915

THE INNOCENT ABROAD.

Out Since Mons : "Well, what sort of a night 'ave ye 'ad?"
Novice (but persistent optimist) : "Oh, alright. 'Ad to get out and rest a bit now and again."

8 December 1915

THAT EVENING STAR-SHELL.
Oh, star of eve, whose tender beam
Falls on my spirit's troubled dream.
Wolfram's Aria in "Tannhauser."

20 October 1915

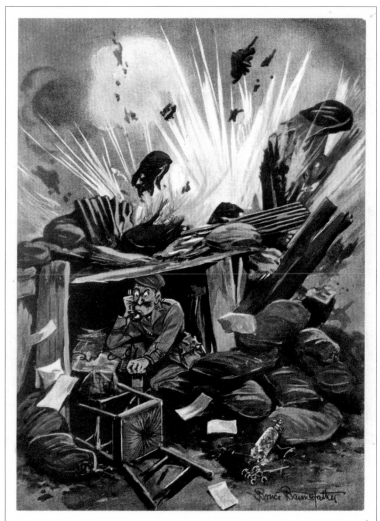

THINGS THAT MATTER.

Colonel Fitz-Shrapnel receives the following message from "G.H.Q."
"Please let us know, as soon as possible, the number of tins of raspberry jam issued to you last Friday."

17 November 1915

"ONCE UPON A TIME"

25 December 1918

Futurist Fiction

Of course, there is no doubt the war will affect romantic fiction. Extract from a 1944 magazine story: "Raising her gas-mask, he raided her mud-stained, crater-like mouth with a barrage of kisses"

BY CAPTAIN BRUCE BAIRNSFATHER

4 December 1918

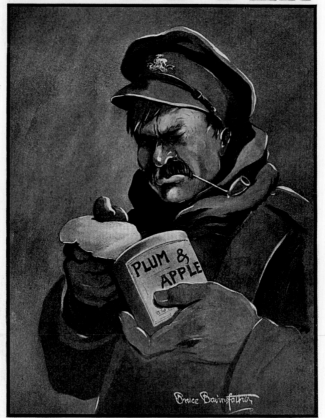

Fairly Tree'd

Owing to dawn breaking sooner than he anticipated, that inventive fellow, Private Jones, has a trying time with his latest creation :—"The Little Plugstreet" (The Sniper's Friend)

BY CAPT. BRUCE BAIRNSFATHER

26 January 1916

73

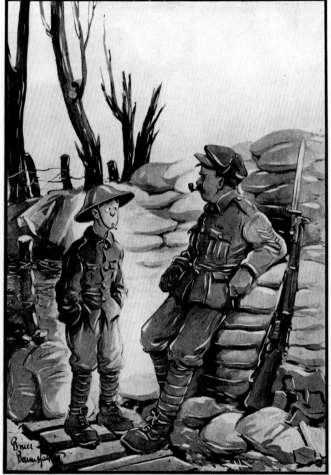

MORE "FRAGMENTS FROM FRANCE"

The Long and the Short of It

PASSED BY CENSOR

UP LAST DRAFT: "I suppose you 'as to be careful 'ow you looks over the parapet about 'ere"
OUT SINCE MONS: "You needn't worry me lad, the rats are going to be your only trouble"

BY CAPTAIN BRUCE BAIRNSFATHER

30 August 1916

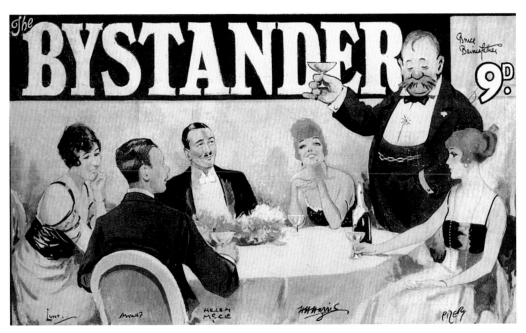

Bystander cover masthead showing a collaboration between several Bystander artists including H.H. Harris, Arthur Watts, Wilmot Lunt, Herbert Pizer and Helen McKie, with Bairnsfather's Old Bill raising his glass to propose a toast, 19 February 1919

Directing the Way at the Front

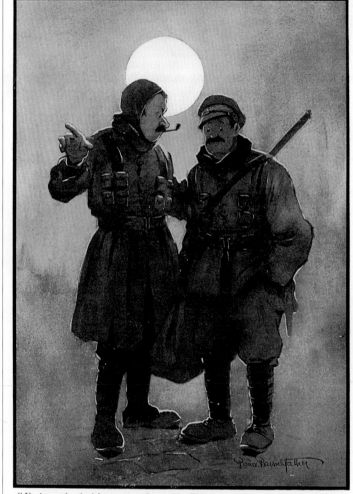

" Ye know the dead 'orse across the road ? Well, keep straight on till ye comes to a perambulator 'longside a Johnson 'ole "

BY CAPT. BRUCE BAIRNSFATHER

1 September 1915

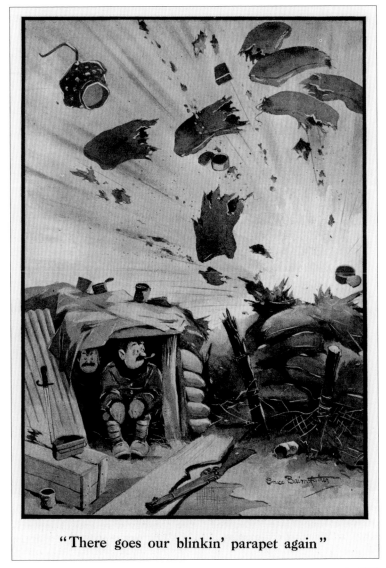

"There goes our blinkin' parapet again"

8 September 1915

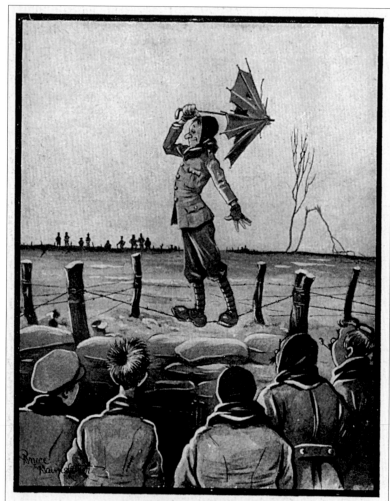

OUR ADAPTABLE ARMIES

Private Jones (late " Zogitoff," the comedy wire artist) appreciably reduces the quantity of HATE per yard of frontage

By Captain Bruce Bairnsfather

24 November 1915

Humours from the Front—No. 33

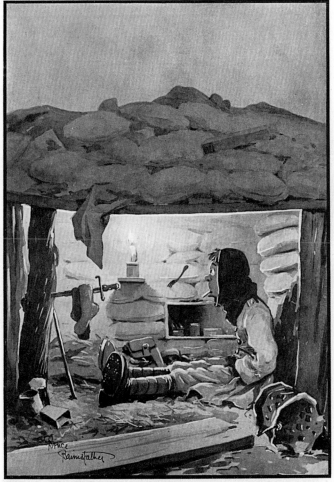

WHEN ONE WOULD LIKE TO START AN OFFENSIVE ON ONE'S OWN

RECIPE FOR FEELING LIKE THIS—Bully, biscuits, no coke, and leave just cancelled

BY CAPT. BRUCE BAIRNSFATHER

[*Captain Bairnsfather's sketches, of which thirty-three have now been published, appear exclusively in "The Bystander" each week.—*ED.]

12 January 1916

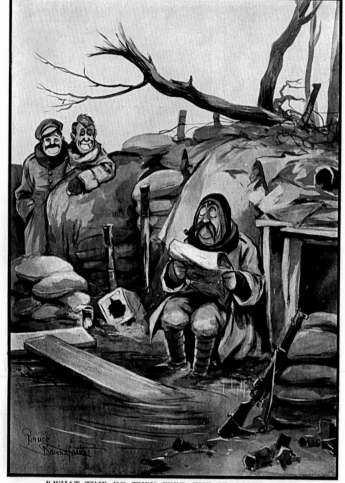

MORE "FRAGMENTS FROM FRANCE"

Happy Memories of the Zoo

"WHAT TIME DO THEY FEED THE SEA-LIONS, ALF?"

BY CAPTAIN BRUCE BAIRNSFATHER

[Captain Bairnsfather's sketches appear exclusively in "The Bystander" each week.—ED.]

23 February 1916

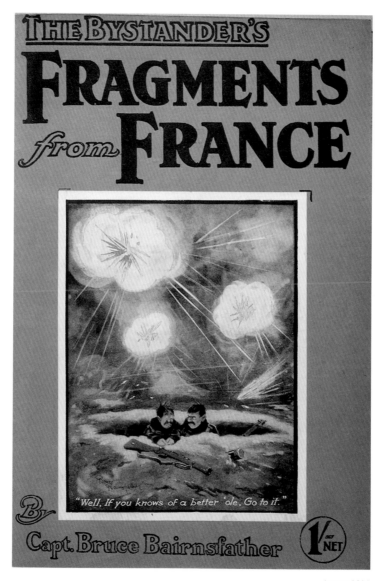

January 1916

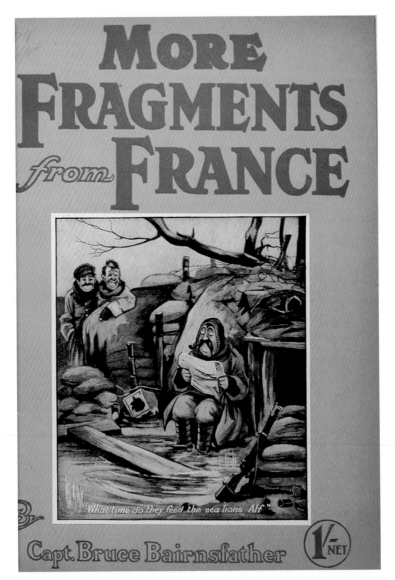

July 1916

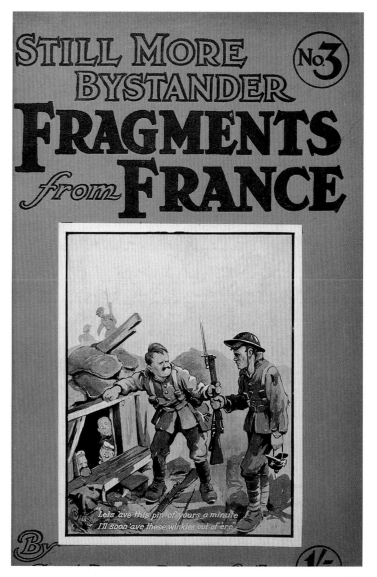

January 1917

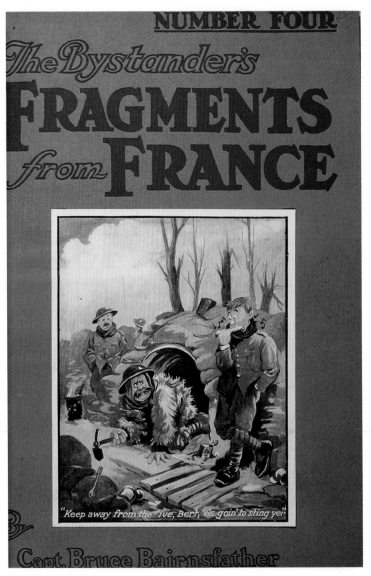

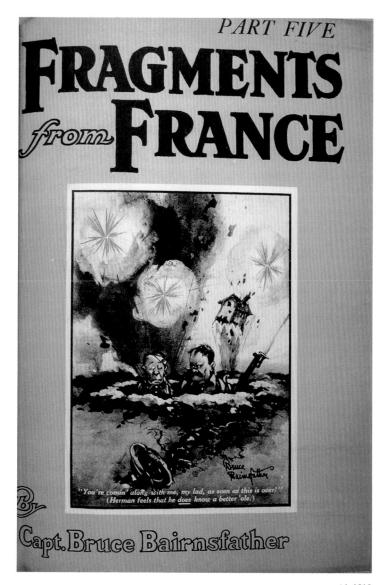

July 1918

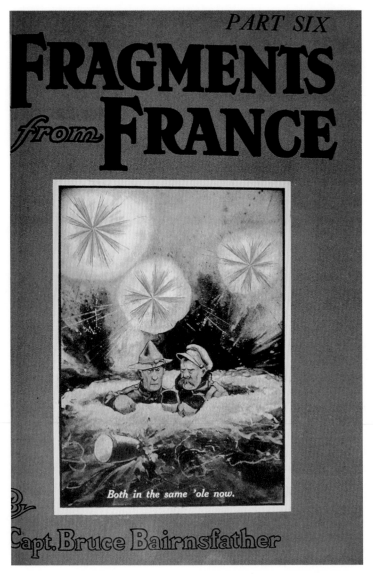

November 1918

December 1918

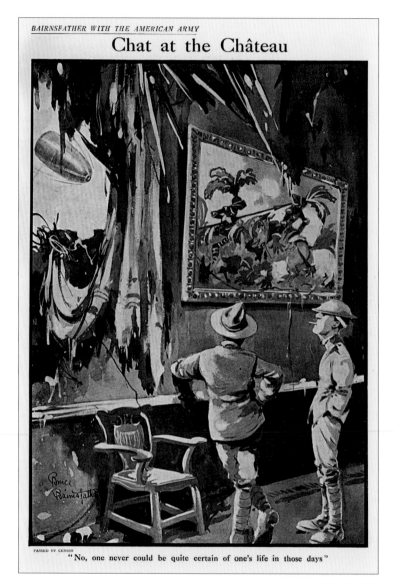

BAIRNSFATHER WITH THE AMERICAN ARMY

Chat at the Château

"No, one never could be quite certain of one's life in those days"

2 October 1918

The Wrong Theatre

PASSED BY CENSOR

Whenever that German searchlight is turned on our trench, we have a lot of trouble with Private Harold Montgomery (the ex-famous actor, who has played in " His Second Sin " over 1,000 times). He *will* try to take a call, which, of course, would be fatal

BY CAPTAIN BRUCE BAIRNSFATHER

6 November 1918

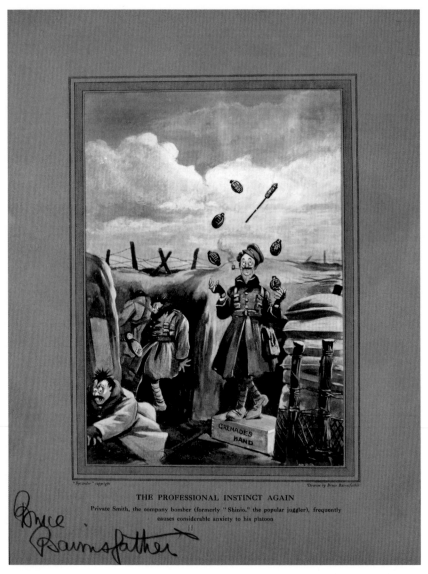

THE PROFESSIONAL INSTINCT AGAIN

Private Smith, the company bomber (formerly "Shinio," the popular juggler), frequently causes considerable anxiety to his platoon

27 October 1915

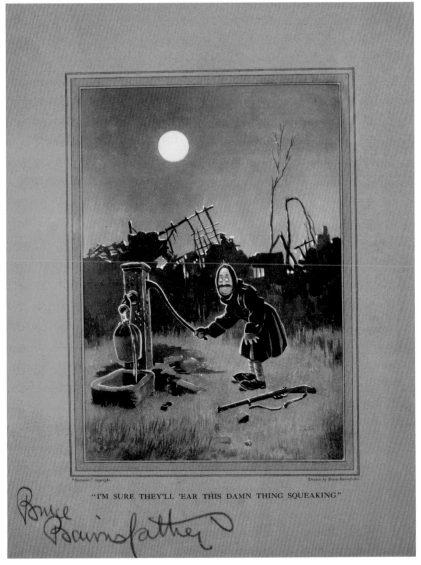

"I'M SURE THEY'LL 'EAR THIS DAMN THING SQUEAKING"

1916

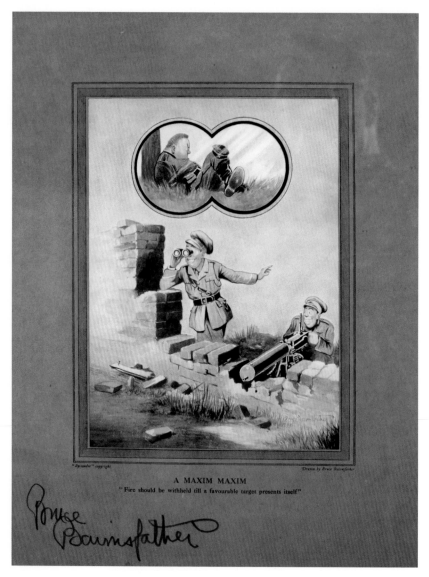

A MAXIM MAXIM
"Fire should be withheld till a favourable target presents itself"

1916

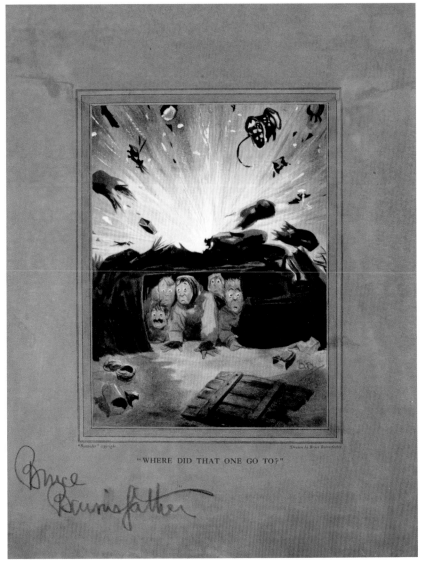

"WHERE DID THAT ONE GO TO?"

31 March 1915

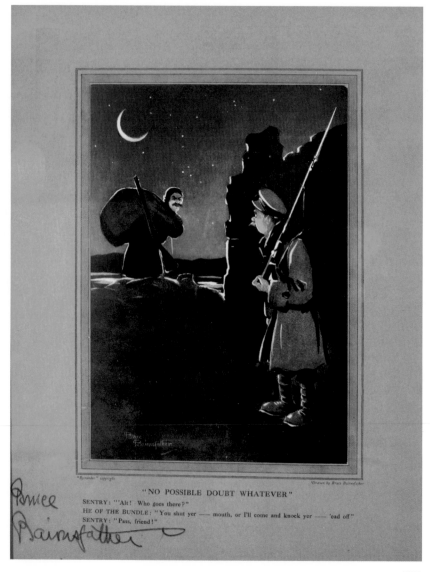

"NO POSSIBLE DOUBT WHATEVER"

SENTRY: "'Alt! Who goes there?"
HE OF THE BUNDLE: "You shut yer —— mouth, or I'll come and knock yer —— 'ead off"
SENTRY: "Pass, friend!"

1916

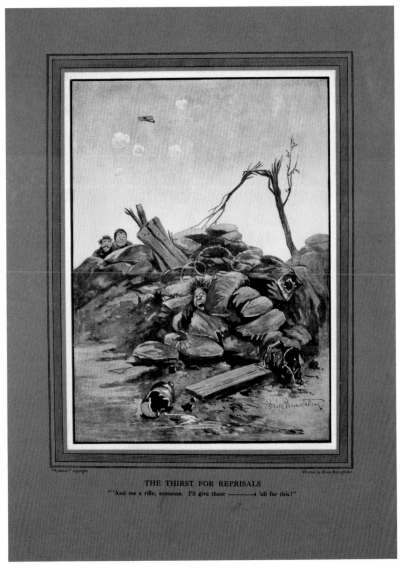

8 December 1915

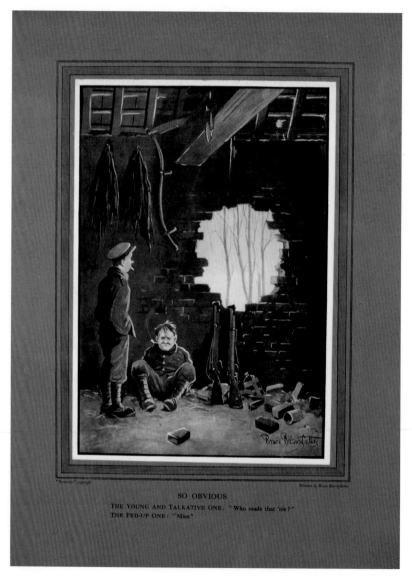

SO OBVIOUS

THE YOUNG AND TALKATIVE ONE: "Who made that 'ole?"
THE FED-UP ONE: "Mice"

1916

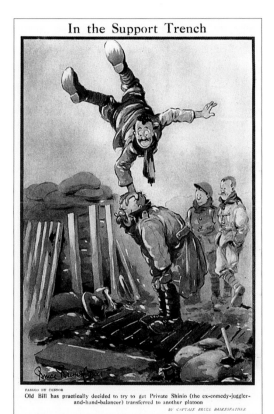

In the Support Trench

PASSED BY CENSOR

Old Bill has practically decided to try to get Private Shinio (the ex-comedy-juggler-and-hand-balancer) transferred to another platoon

BY CAPTAIN BRUCE BAIRNSFATHER

9 May 1917

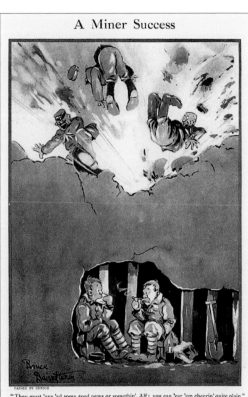

A Miner Success

PASSED BY CENSOR

"They must 'ave 'ad some good news or somethin', Alf; you can 'ear 'em cheerin' quite plain"

BY CAPTAIN BRUCE BAIRNSFATHER

16 May 1917

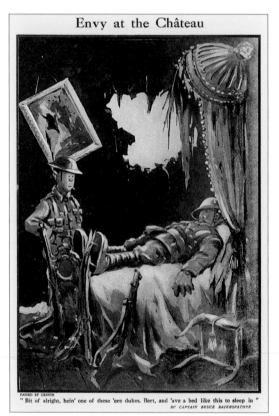

Envy at the Château

PASSED BY CENSOR

" Bit of alright, bein' one of these 'ere dukes, Bert, and 'ave a bed like this to sleep in "

BY CAPTAIN BRUCE BAIRNSFATHER

" Then out strode bold Ol'Billius, And Bertus, out strode he . . ."

PASSED BY CENSOR

War is an ugly business, but it wouldn't look half so bad if only we took a few tips from the ancients as regards costume

BY CAPTAIN BRUCE BAIRNSFATHER

4 July 1917

18 July 1917

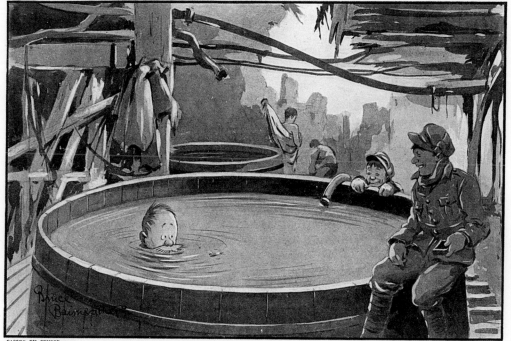

At the Brewery Baths

PASSED BY CENSOR

" You chuck another sardine at me, my lad, and you'll hear from my solicitors "

BY CAPTAIN BRUCE BAIRNSFATHER

6 June 1917

Second-Lieut. Mabel Smells Powder
(No novelty)

PASSED BY CENSOR

" There you are, Bert; I told you we'd 'ave 'em 'ere before we'd finished "

BY CAPTAIN BRUCE BAIRNSFATHER

1 August 1917

Old Billisation

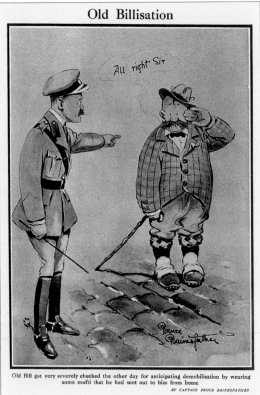

All right Sir

Old Bill got very severely checked the other day for anticipating demobilisation by wearing some mufti that he had sent out to him from home

BY CAPTAIN BRUCE BAIRNSFATHER

26 February 1919

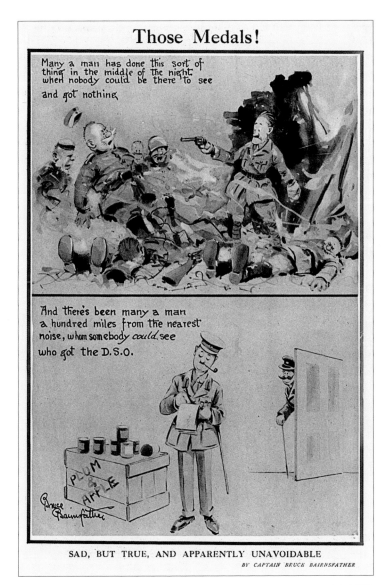

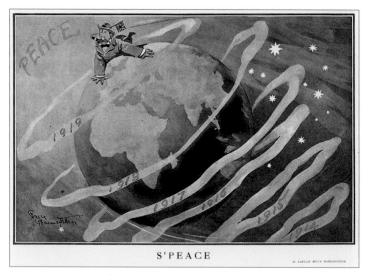

7 May 1919

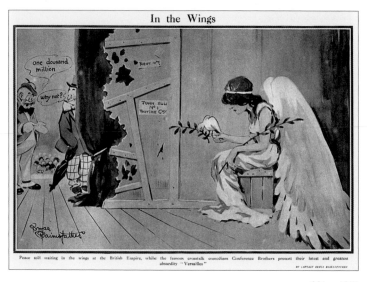

25 June 1919

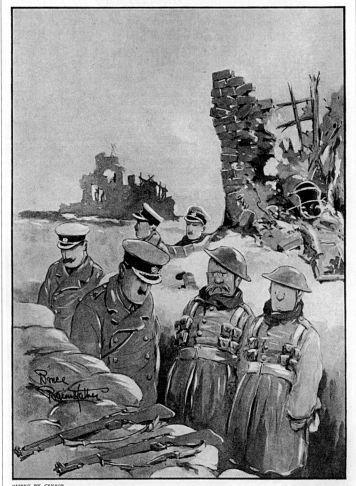

Birds of Ill Omen

PASSED BY CENSOR

"There's evidently goin' to be an offensive around 'ere, Bert"

BY CAPTAIN BRUCE BAIRNSFATHER

22 August 1917

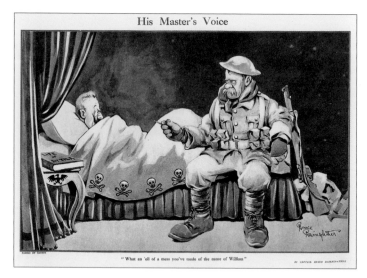

12 September 1917

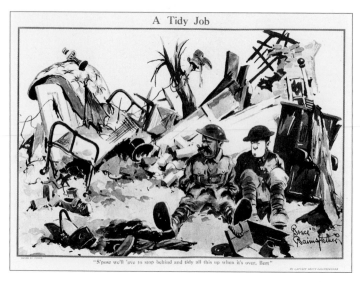

26 September 1917

A Small Potato

" What's that hat doin' floatin' round there, sergeant ? "
" I think that's Private Murphy sittin' down, sir "

3 April 1918

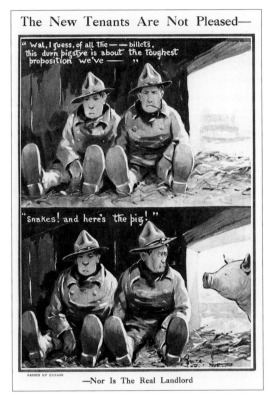

10 April 1918

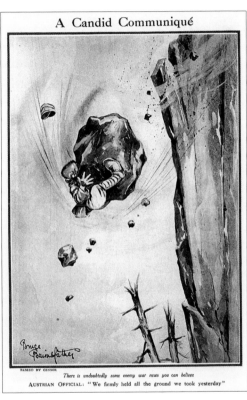

10 April 1918

The Smoke of Battle

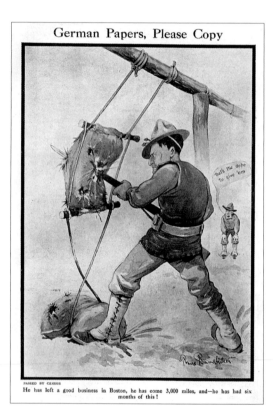

PASSED BY CENSOR

When rolling your Bull Durham, the most important thing is to keep the hands steady
so that the tobacco lies evenly on the palm

17 April 1918

German Papers, Please Copy

PASSED BY CENSOR

He has left a good business in Boston, he has come 3,000 miles, and—he has had six
months of this !

24 April 1918

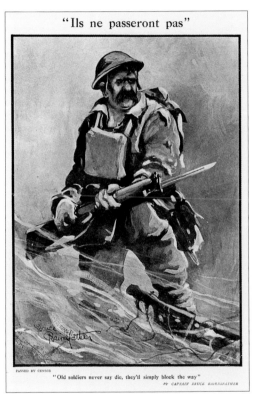

"Ils ne passeront pas"

PASSED BY CENSOR

"Old soldiers never say die, they'll simply block the way"

BY CAPTAIN BRUCE BAIRNSFATHER

24 April 1918

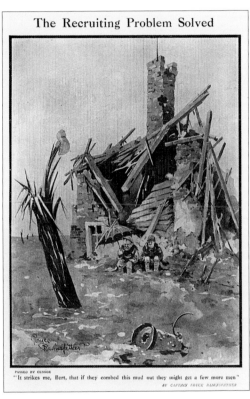

The Recruiting Problem Solved

PASSED BY CENSOR

"It strikes me, Bert, that if they combed this mud out they might get a few more men"

BY CAPTAIN BRUCE BAIRNSFATHER

24 April 1918

The Raid

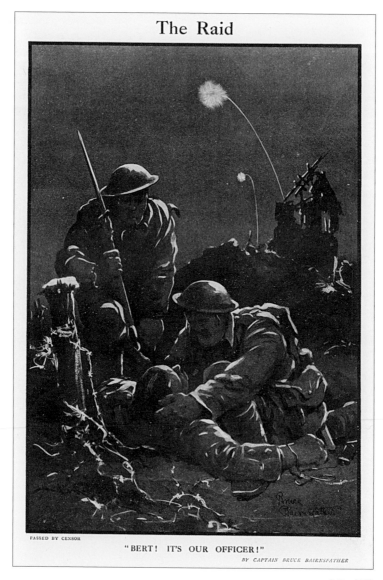

"BERT! IT'S OUR OFFICER!"

BY CAPTAIN BRUCE BAIRNSFATHER

8 May 1918

Hardly a "Home from Home"

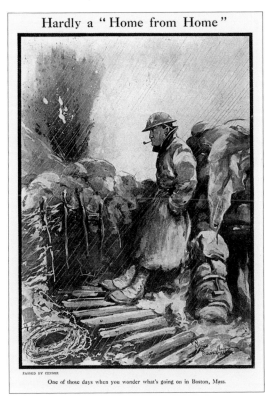

PASSED BY CENSOR

One of those days when you wonder what's going on in Boston, Mass.

15 May 1918

Circumstances Alter Cases

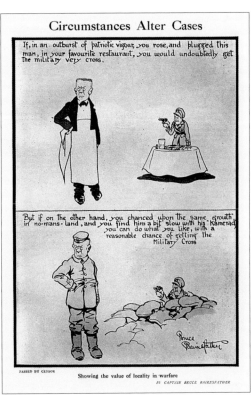

If, in an outburst of patriotic vigour, you rose, and plugged this man, in your favourite restaurant, you would undoubtedly get the military very cross.

But if on the other hand, you chanced upon the same "growth" in no-mans-land, and you find him a bit slow with his "Kamerad" you can do what you like, with a reasonable chance of getting the Military Cross

PASSED BY CENSOR

Showing the value of locality in warfare

BY CAPTAIN BRUCE BAIRNSFATHER

15 May 1918

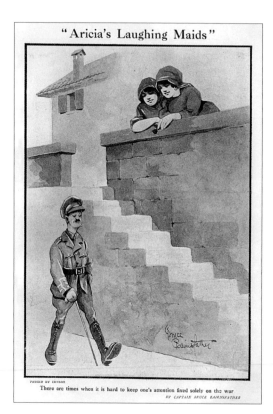

22 May 1918

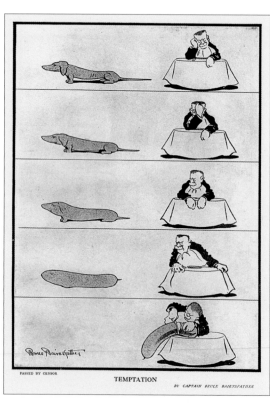

29 May 1918

Vindictive, eh?

PASSED BY CENSOR

"I wonder what they'll do with Old Bill when the war's over, Bert?"
"I dunno; 'ave 'im filled with concrete and sunk somewhere, I expect"

12 June 1918

113

Out ! !

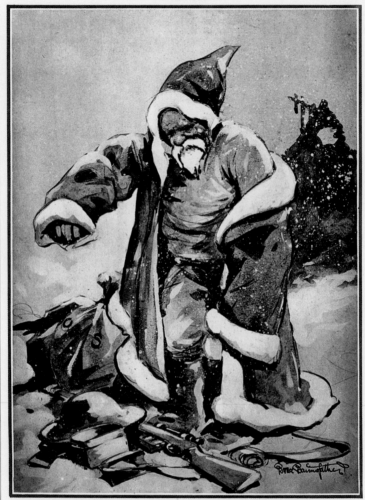

—AND MAY HE NEVER BE "CALLED UP" AGAIN!

BY CAPTAIN BRUCE BAIRNSFATHER

24 December 1919

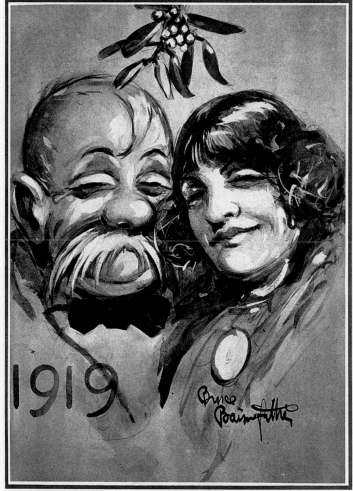

31 December 1919

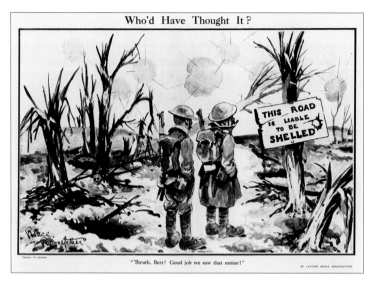

26 June 1918

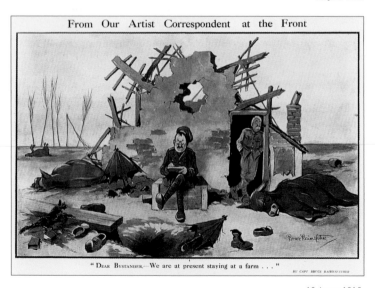

18 August 1915

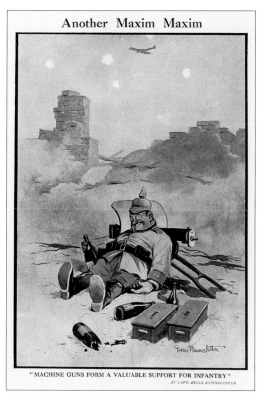

Another Maxim Maxim

"MACHINE GUNS FORM A VALUABLE SUPPORT FOR INFANTRY"
BY CAPT. BRUCE BAIRNSFATHER

22 September 1915

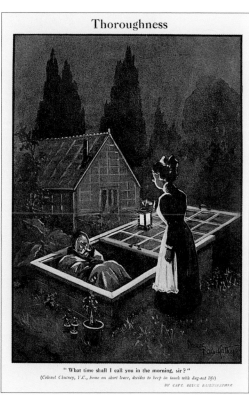

Thoroughness

" What time shall I call you in the morning, sir ? "
(Colonel Chutney, V.C., home on short leave, decides to keep in touch with dug-out life)
BY CAPT. BRUCE BAIRNSFATHER

13 October 1915

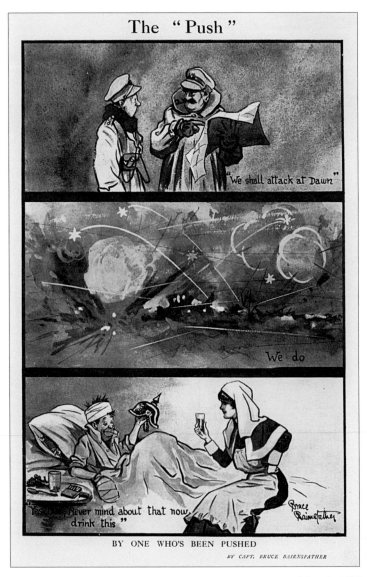

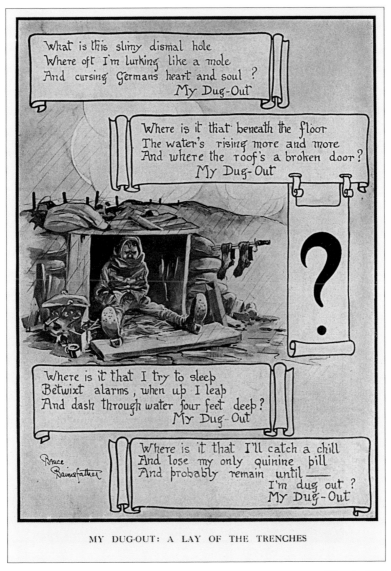

What is this slimy dismal hole
Where oft I'm lurking like a mole
And cursing Germans heart and soul ?
 My Dug-Out

Where is it that beneath the floor
The water's rising more and more
And where the roof's a broken door?
 My Dug-Out

Where is it that I try to sleep
Betwixt alarms, when up I leap
And dash through water four feet deep?
 My Dug-Out

Where is it that I'll catch a chill
And lose my only quinine pill
And probably remain until——
 I'm dug out ?
 My Dug-Out

MY DUG-OUT: A LAY OF THE TRENCHES

8 December 1915

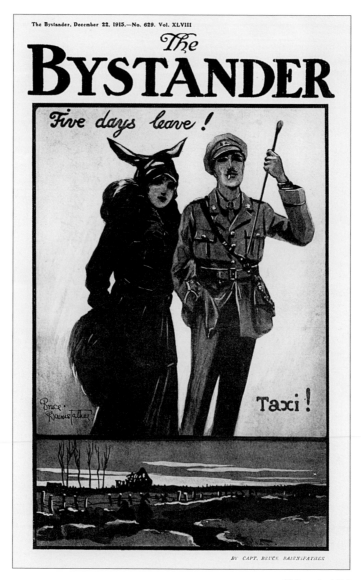

22 December 1915

Humours from the Front—No. 30

"And to think that it's the same dear old moon that's looking down on him!"

"This blinkin' moon will be the death of us"

"THE SAME OLD MOON"

BY CAPT. BRUCE BAIRNSFATHER

[Captain Bairnsfather's sketches, of which thirty have now been published, appear exclusively in "The Bystander" each week.—ED.]

22 December 1915

Humours from the Front—No. 32

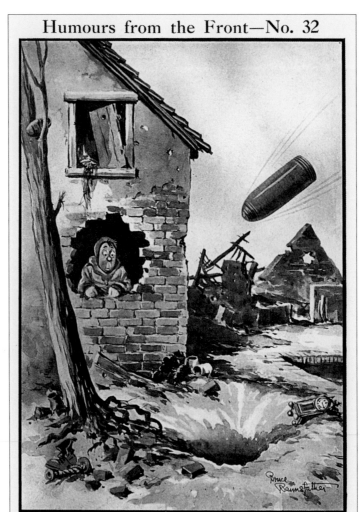

SITUATION SHORTLY VACANT

In an old-established house in France an opening will shortly occur for a young man,
with good prospects of getting a rise

BY CAPT. BRUCE BAIRNSFATHER

[*Capt. Bairnsfather's sketches, of which thir'y-two have now been published, appear exclusively in "The Bystander"
each week.—Ed.*]

5 January 1916

Old Saws and New Meanings—By Bairnsfather

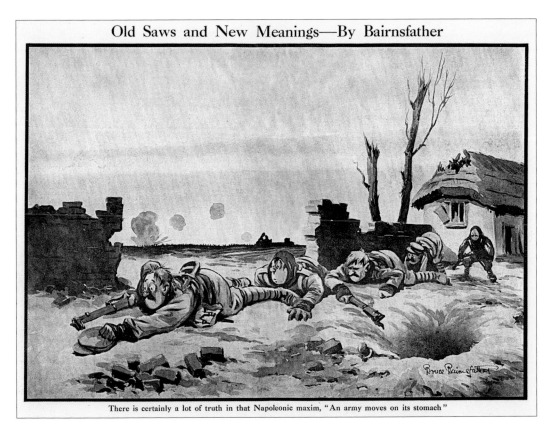

There is certainly a lot of truth in that Napoleonic maxim, "An army moves on its stomach"

19 January 1916

19 April 1916

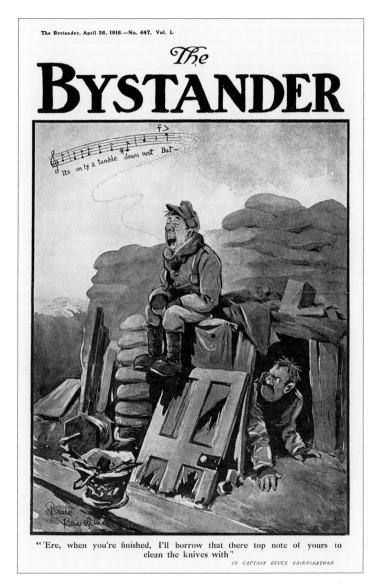

26 April 1916

Valuable Fragment from Flanders

IT ALL COMES TO THIS IN TIME

"This interesting fragment found near Ypres (known to the ancients as Wipers) throws a light on a subject which has long puzzled science, i.e., what was the origin and meaning of those immense zigzag slots in the ground stretching from Ostend to Belfort? There is no doubt that there was some inter-tribal war on at this period."—*Extract from "The Bystander,"* A.D. 4916

BY CAPT. BRUCE BAIRNSFATHER

26 April 1916

126

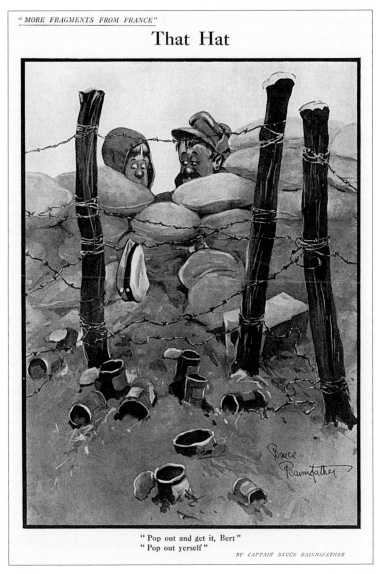

"MORE FRAGMENTS FROM FRANCE"

That Hat

"Pop out and get it, Bert"
"Pop out yerself"

BY CAPTAIN BRUCE BAIRNSFATHER

3 May 1916

"MORE FRAGMENTS FROM FRANCE"

The Historical Touch

"Well, Alfred, 'ow are the cakes?"

"Well, Alfred, 'ow are the cakes?"

BY CAPTAIN BRUCE BAIRNSFATHER

[Captain Bairnsfather's sketches appear exclusively in "The Bystander" each week.—ED.]

10 May 1916

The Dud Shell—

—Or the Fuse Top Collector

"Give it a good 'ard 'un, Bert, you can generally 'ear 'em fizzin' a bit first if they are a-goin' to explode"

BY CAPTAIN BRUCE BAIRNSFATHER

17 May 1916

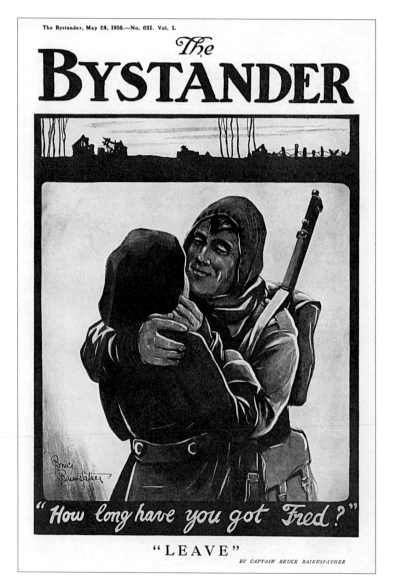

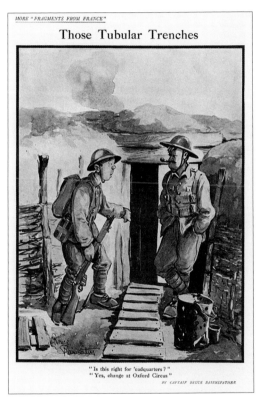

MORE "FRAGMENTS FROM FRANCE"

Those Tubular Trenches

" Is this right for 'eadquarters ? "
" Yes, change at Oxford Circus "

BY CAPTAIN BRUCE BAIRNSFATHER

24 May 1916

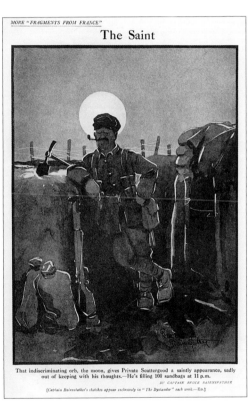

MORE "FRAGMENTS FROM FRANCE"

The Saint

That indiscriminating orb, the moon, gives Private Scattergood a saintly appearance, sadly out of keeping with his thoughts.—He's filling 100 sandbags at 11 p.m.

BY CAPTAIN BRUCE BAIRNSFATHER

[Captain Bairnsfather's sketches appear exclusively in " The Bystander" each week.—ED.]

7 June 1916

Urgent

" Quick, afore this comes down ! "

BY CAPTAIN BRUCE BAIRNSFATHER

5 July 1916

Leave

DEP.: PADDINGTON 2.15. ARR.: HOME 4

BY CAPTAIN BRUCE BAIRNSFATHER

25 October 1916

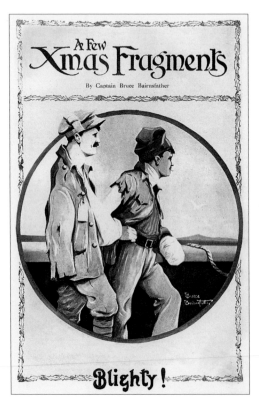

27 November 1916

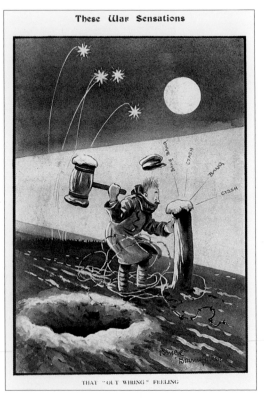

27 November 1916

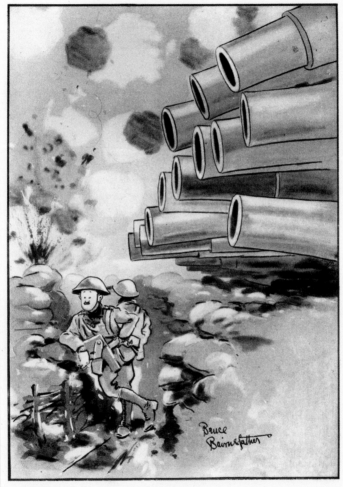

Unappetising

PASSED BY CENSOR

Moments when the Savoy, the Alhambra, and the Piccadilly Grill seem very far away (the offensive starts in half-an-hour)

BY CAPTAIN BRUCE BAIRNSFATHER

28 February 1917

An In-fringe-ment

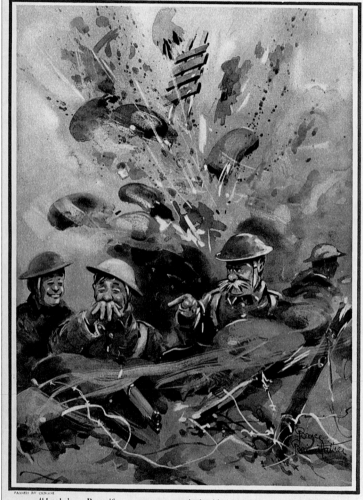

"Look 'ere, Bert, if you wants to remain in this 'ere trench be'ave yerself"

BY CAPTAIN BRUCE BAIRNSFATHER

2 October 1918

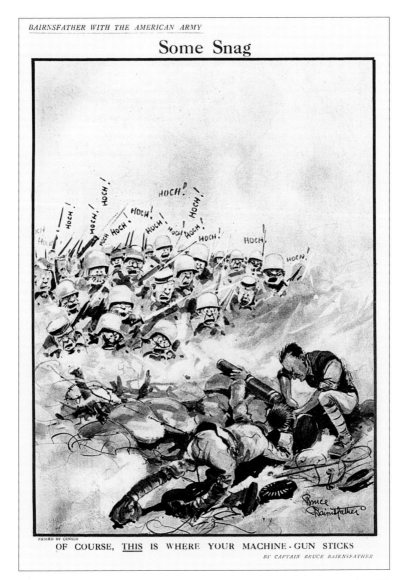

9 October 1918

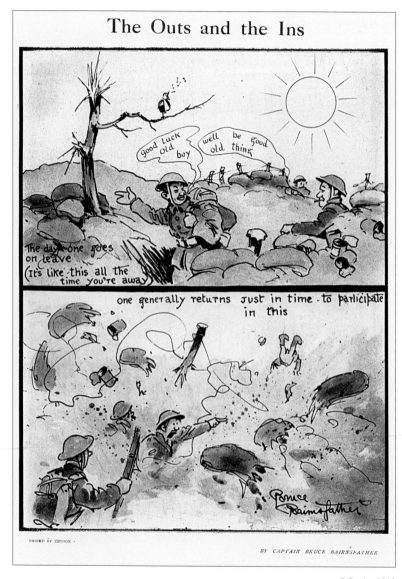

9 October 1918

The Best Laid Schemes of Mice and Men—

PASSED BY CENSOR

Old Bill had thought of a splendid idea for the next battle, and, frankly, was rather hurt when a Staff Officer condemned it

BY CAPTAIN BRUCE BAIRNSFATHER

23 October 1918

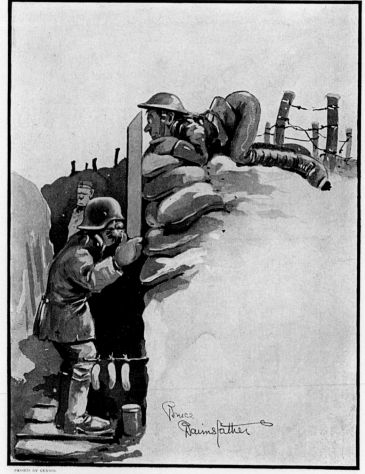

Looking for Trouble

"The rash habit Private Lovebird has of sharing the same periscope with the opposition across the way is bound to lead to trouble"

BY CAPTAIN BRUCE BAIRNSFATHER

13 November 1918

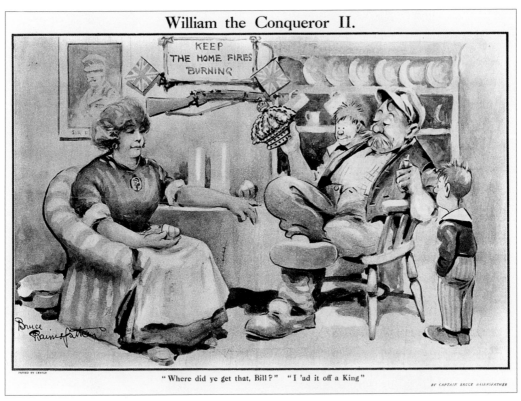

27 November 1918

11 December 1918

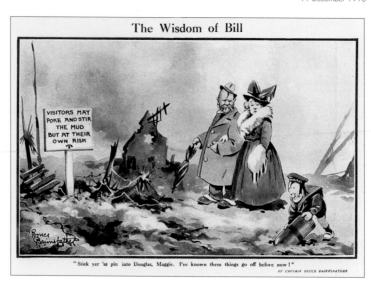

18 December 1918

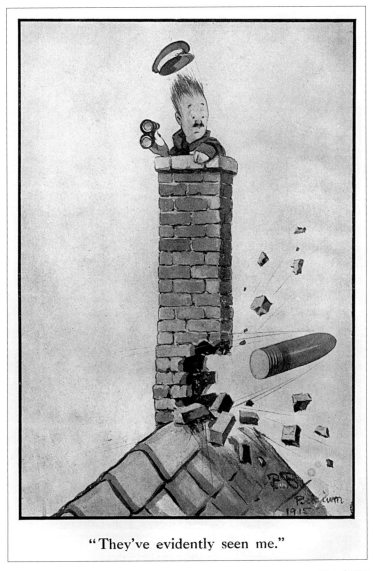

"They've evidently seen me."

21 April 1915

ACKNOWLEDGEMENTS

In the process of compiling this book, I am indebted to Tonie and Valmai Holt for their help in providing the front cover of *The Bystander* magazine's Christmas 1918 number. For anyone wishing to discover more about Bairnsfather and his world, I would strongly recommend their definitive biography *In Search of a Better 'Ole*. *The Illustrated London News* archive includes a full run of *The Bystander*, part of a stable of magazines once known as the 'Great Eight' and is, without a doubt, Bairnsfather's spiritual home. Thanks also to David and Judith Cohen for their interest and help in contributing images to this book. And finally, if you have been bitten by the Bairnsfather bug, you may be interested in joining the Bruce Bairnsfather Society (www.brucebairnsfather.org.uk) run by the knowledgeable and dedicated Mark Warby.

All images in this book are taken from *The Illustrated London News* archive, housed and managed at Mary Evans Picture Library, except for the following:

David Cohen Fine Art/Mary Evans Picture Library: pp. 15 (top), 22, 33 (top), 34, 35, 65, 66, 67, 68, 69, 81, 82, 83, 84, 85, 86; H. M. Bateman Designs Ltd/ILN/Mary Evans Picture Library: p. 38; Lucinda Gosling/Mary Evans Picture Library: pp. 10, 13; Mary Evans Picture Library: p. 21; Onslows Auctioneers/Mary Evans Picture Library: pp. 15 (bottom), 28, 90, 91, 92, 93, 94, 95, 96; Ronald Grant Film Archive/Mary Evans Picture Library: p. 8; Tonie & Valmai Holt: p. 87